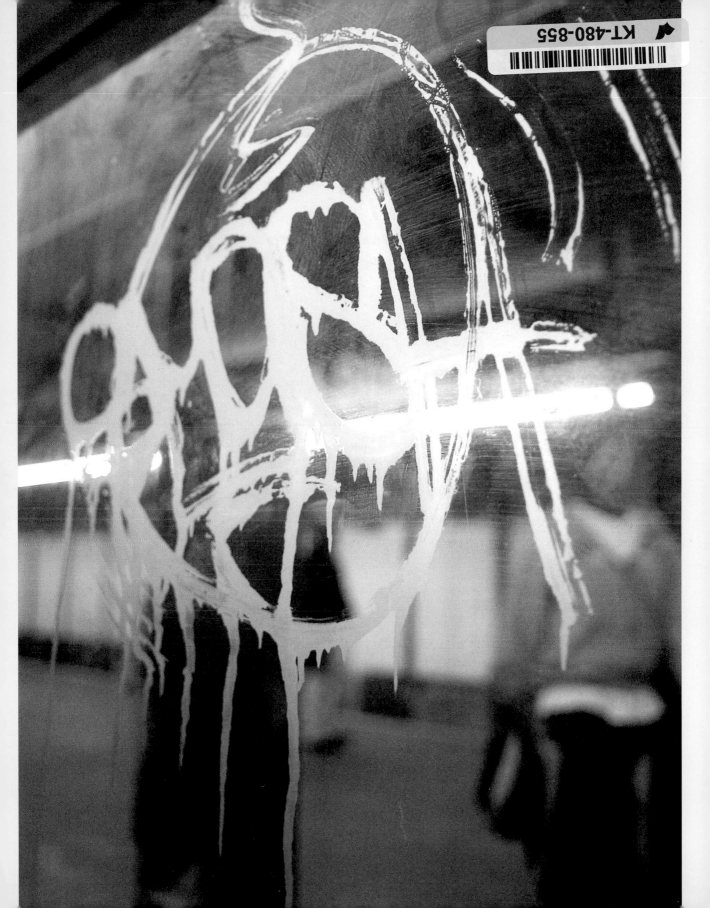

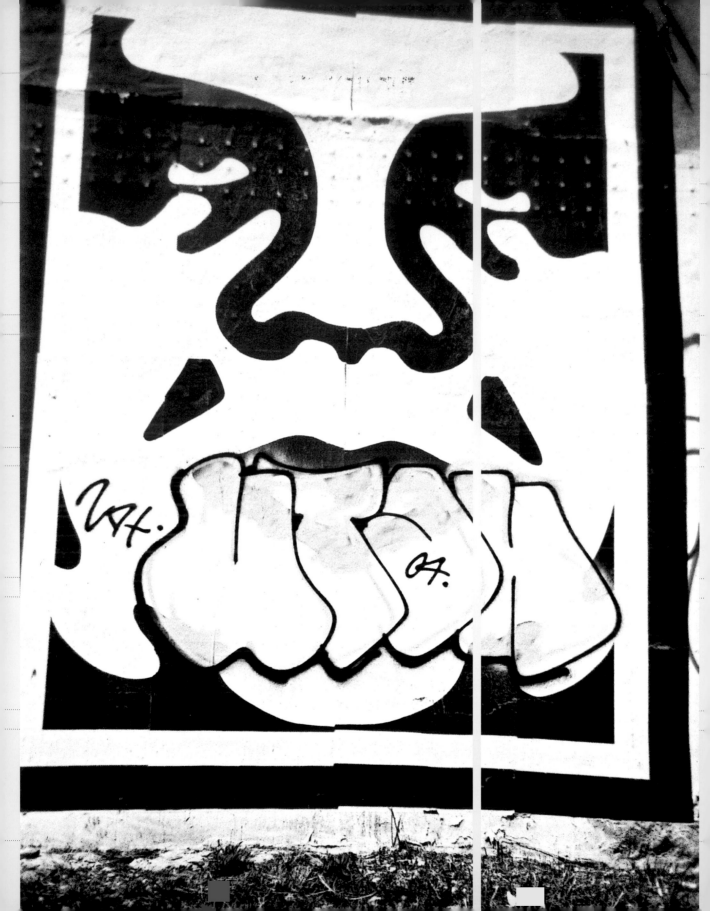

GRAFFITI NYC

GRAFFITI NYC

Hugo Martinez

with photographs by
NATO

PRESTEL
Munich Berlin London New York

dedicated to MERCHE

and to the memory of
A-1, DREAM, JULIO
204, KROME 100,
PG, SPEC, STITCH 1,
TOPCAT 126, T-REX
131, and VE

© Hugo Martinez and Prestel Verlag, Munich, Berlin,
London, New York 2006
© for photographs and artworks, see Photography
Credits, pages148–149

front cover top: DARKS by NATO, Brooklyn, 2004
front cover bottom: NOXER by DSENSE, Manhattan,
2004 aerosol
back cover right: MQ by DESENCE, Queens,
2002 aerosol
back cover left: RATE by NATO, Brooklyn,
2002 aerosol

GRAFFITI NYC is a production of ALL CITY and is
sponsored in part by ALL CITY GROUP, LTD and
PEDIATRICS 2000

produced by Hugo Martinez, All City Group Ltd.,
New York
editorial direction: Christopher Lyon
graphic design: Melanie van Haaren, The Hague
photo editing: Antonio Zaya and NATO, New York
text editing: Ken Bensinger and Antonio Zaya,
New York
editorial production: KEZ, NATO, Sabrina Sadeghi,
Nina Siegal, and Robin X, New York
origination: Reproline Mediateam, Munich
printed and bound by Druckerei Uhl, Radolfzell

printed in Germany on acid-free paper

ISBN 3-7913-3673-8
978-3-7813-3673-2

Prestel Verlag
Königinstrasse 9
D-80539 Munich
Germany
Tel. +49 (89) 38 17 09-0
Fax +49 (89) 38 17 09-35

Prestel Publishing Ltd.
4, Bloomsbury Place
London WC1A 2QA
England
Tel. +44 (20) 73 23 50 04
Fax +44 (20) 76 36 80 04

Prestel Publishing
900 Broadway, suite 603
New York, NY 10003
United States of America
Tel. +1 (212) 995 2720
Fax +1 (212) 995 2733
www.prestel.com

Prestel books are available worldwide. Please
contact your nearest bookseller or one of the above
addresses for information concerning your local
distributor.

Library of Congress Control Number: 2006930772

British Cataloguing-in-Publication Data: A catalogue
record for this book is available from the British
Library. The Deutsche Bibliothek holds a record of
this publication in the Deutsche Nationalbibliografie;
detailed bibliographical data can be found under:
http://dnb.ddb.de

...contents

...introduction

Antonio Zaya in collaboration
with Ken Bensinger

The motivating idea in creating this book is that graffiti—or the urban art form commonly called graffiti—has been, since its inception, generally (and indeed intentionally) excluded from the institutional world of art. This book, the first in a series developed by members of New York's ALL CITY think tank, is based on a fundamental conviction that graffiti is not an anthropological phenomenon to be dissected, not a social malady to be cured, but a legitimate aesthetic and cultural movement, born of a revolutionary spirit and a will to resistance.

Graffiti is a powerful assertion of personal identity, invented and nurtured by working-class youth, despite ceaseless efforts by public institutions, corporations, and popular culture to deny the artists' individuality—to turn them into statistics, consumers, and a mass audience. Thanks to messages handed down principally by the mass media, graffiti writers have been stereotyped as delinquent, marginal, or artistically inadequate—an intentional deception that justifies the preconceived idea that this movement is 'antisocial' and 'criminal', and thus without stylistic discriminations or standards of achievement.

At the same time, the tendency to marginalize graffiti has allowed enthusiastic authors to bestow on it a heroic and romantic dimension, as being youthful and cathartic, which supposedly removes it from, or places it in opposition to, the practices of conventional, codified art forms. This equally misleading kind of generalization, which continues to define the popular image of graffiti, has obscured and diminished our understanding and blinded our vision. It prevents us from seeing the revolutionary aspect of graffiti's expression, its culture of resistance to manipulation and censorship; and it keeps us from seeing graffiti as art. Instead we are exposed to a kind of fraud that simplifies and exploits this authentic form of expression of street art. This is, perhaps, because of the form's controversial and difficult socio-political themes; because it questions the exclusive 'ghetto' of contemporary artistic creation; and because allowing it to function as the work of individual artists dispels the exclusively criminal image that remains associated with graffiti.

Yet the fact that the expression of graffiti is not mediated by an institutional system of schools, galleries, and museums does not mean that it is without a structure. Within New York, there is a recognized history, dating back decades now, with specific individuals recognized for their innovations and contributions. There are distinct styles with recognized starting points. And there are individuals who have become facilitators and enablers, critics, chroniclers, and publicists—defenders of graffiti as an art form.

This publication demonstrates the variety of styles and approaches that characterize the selected artists, putting in evidence all of their expressive and discursive depth and at the same time refuting the tendency to generalize them. In this sense, the choice of these artists not only highlights the groundbreaking role of the most recognized artists of this form of street expression in New York City, but also the visible influence that they have had on other 'writers' of their generation and succeeding ones, working simultaneously and subsequently in other corners of the city, equally abandoned.

This book reveals the vitality, urgency, character and artistic merit of this spontaneous, antiauthoritarian movement, one that has spread across the world. It's a growth that continues despite the ongoing repression that the form has endured since its emergence. At the same time, the book aims to include a generous selection of work by each of the selected artists, in order to show the expressive and discursive richness characteristic of graffiti culture. No book on contemporary graffiti can be definitive. This constantly changing, ephemeral art form can only be experienced in the vast 'gallery' of NYC's streets, walls, rooftops, tunnels, trucks, and mass transit system. But as with any art form, understanding it, recognizing its artistic personalities and the styles of individual writers, can make the viewer's experience more rewarding.

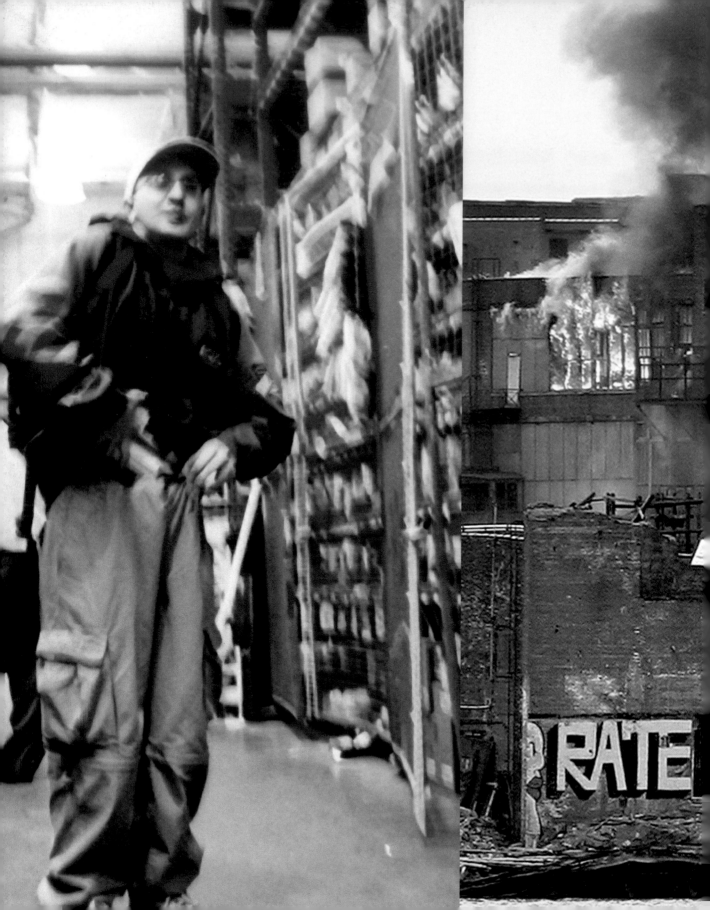

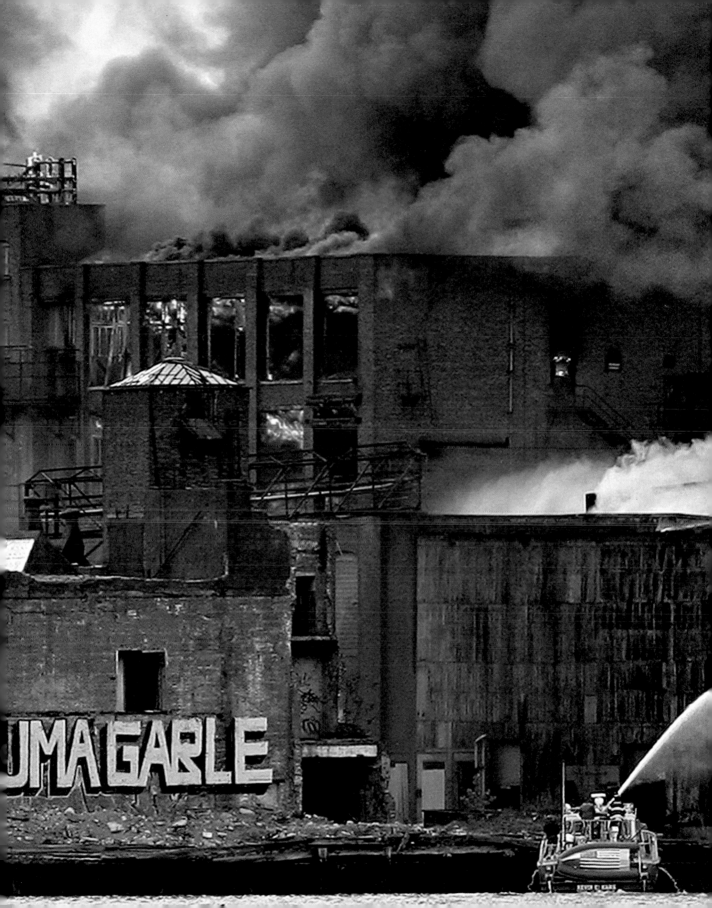

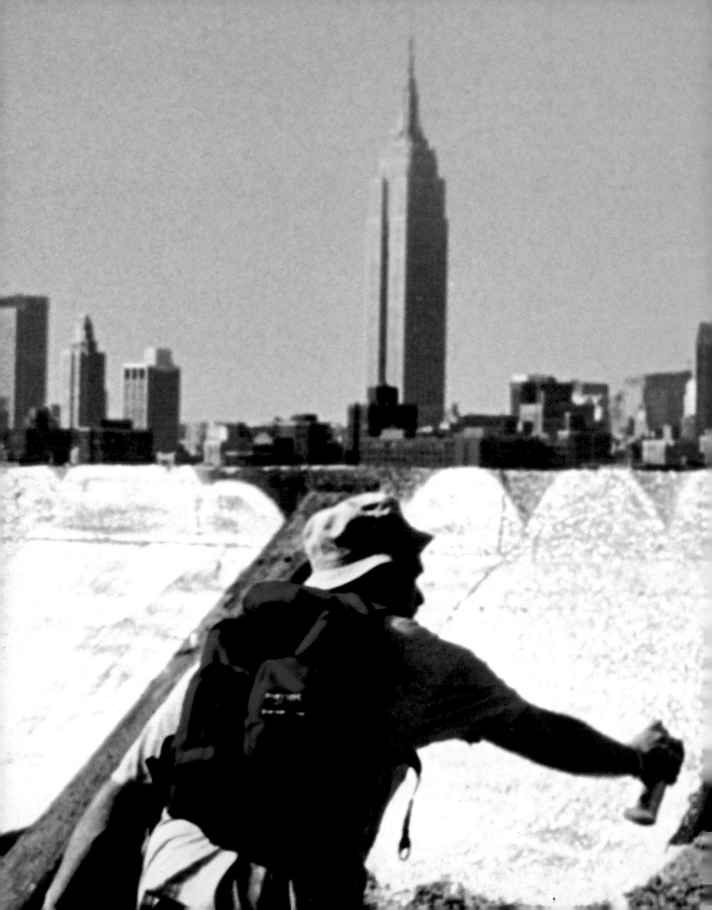

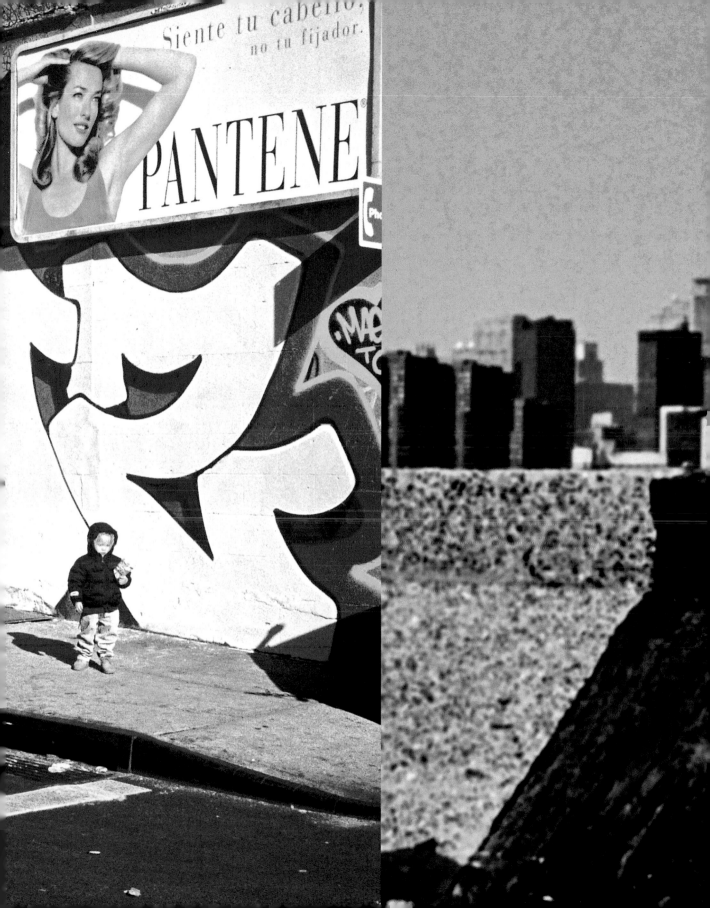

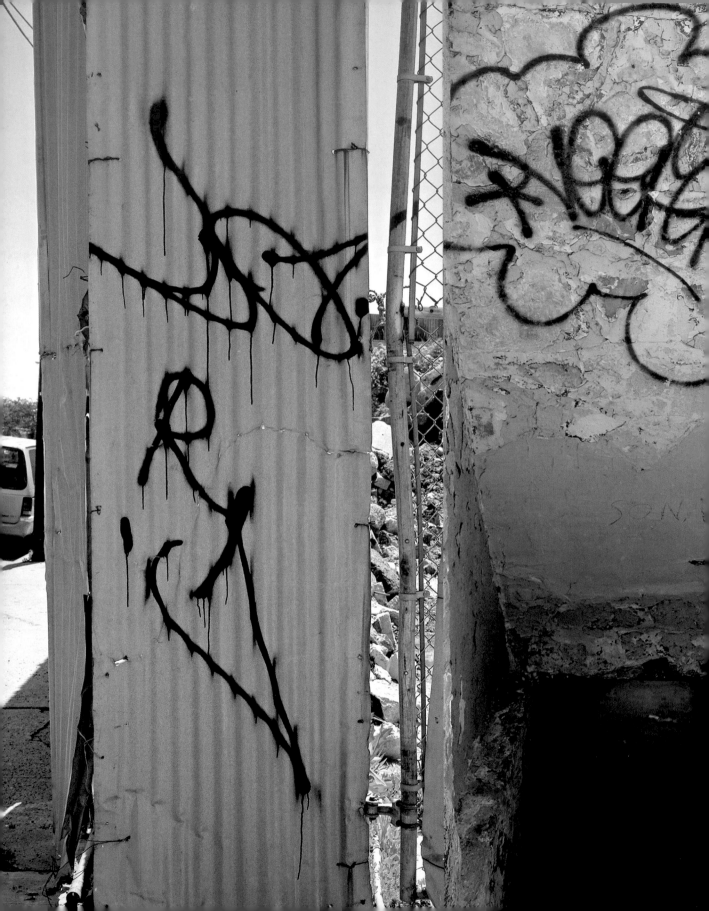

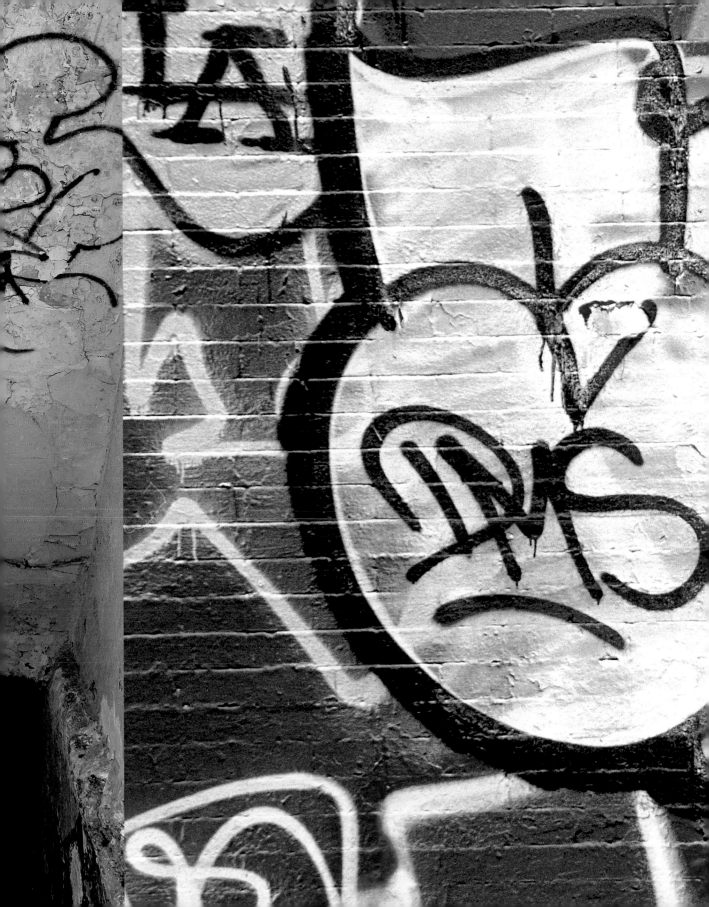

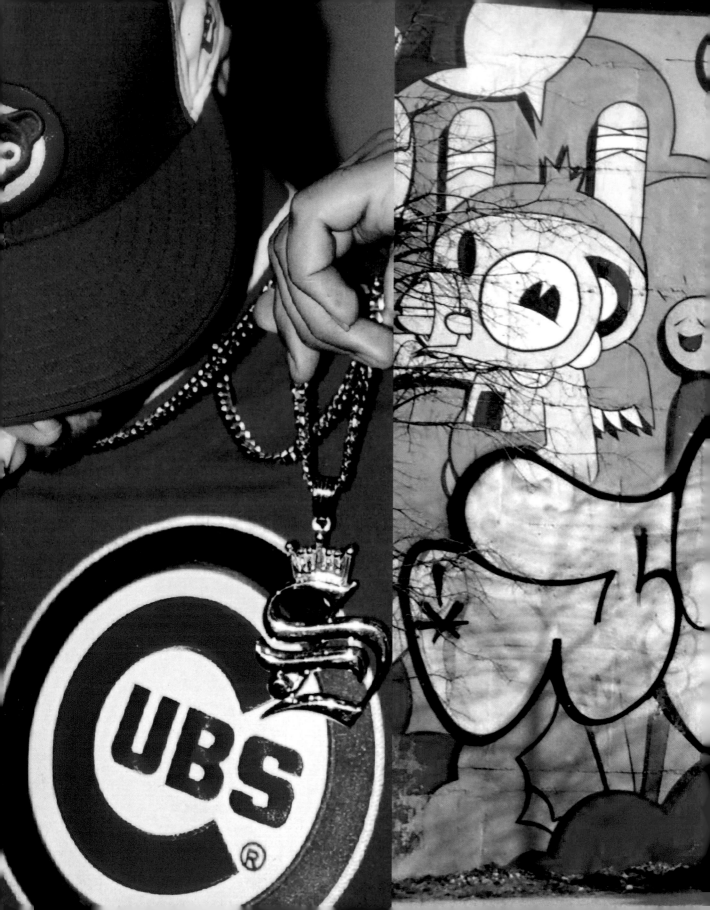

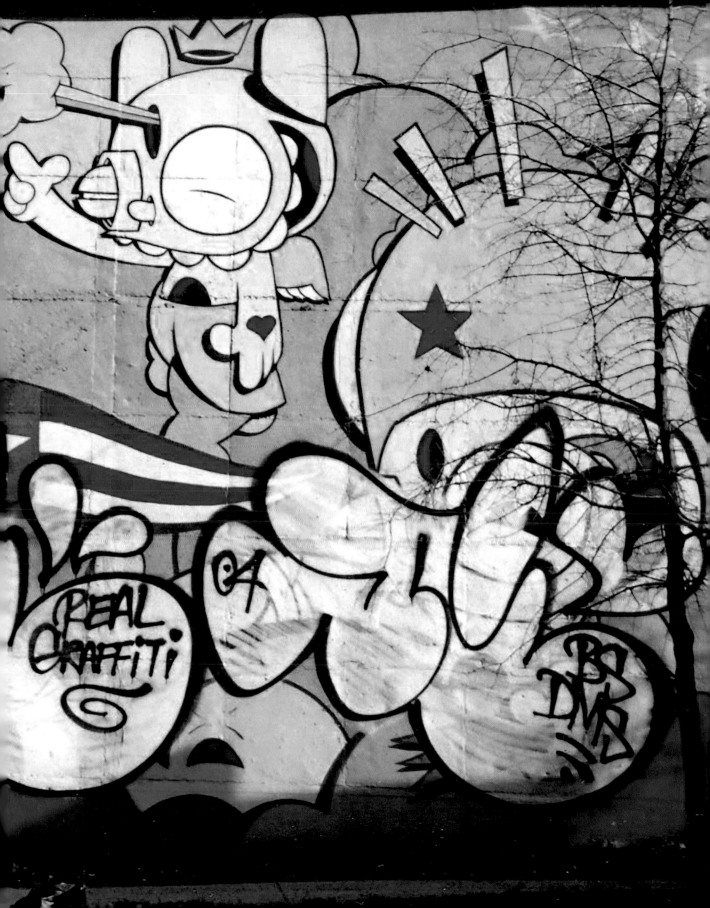

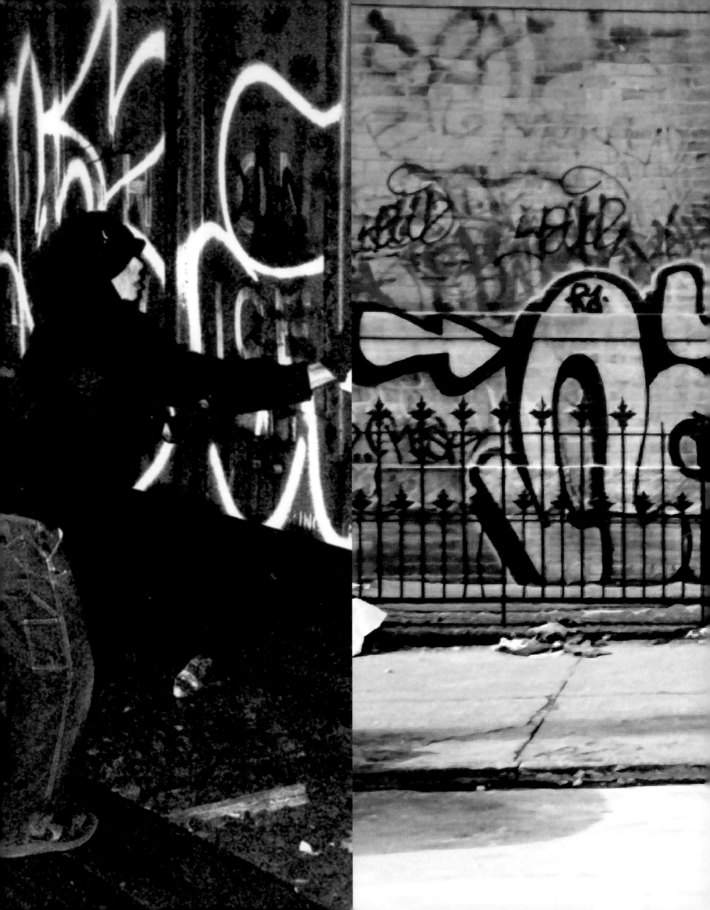

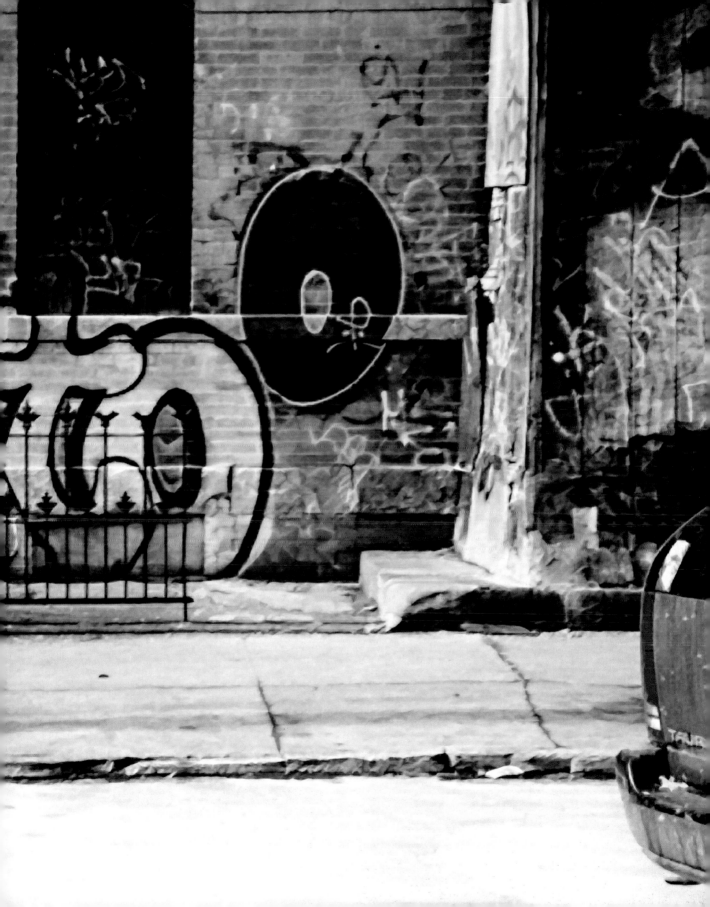

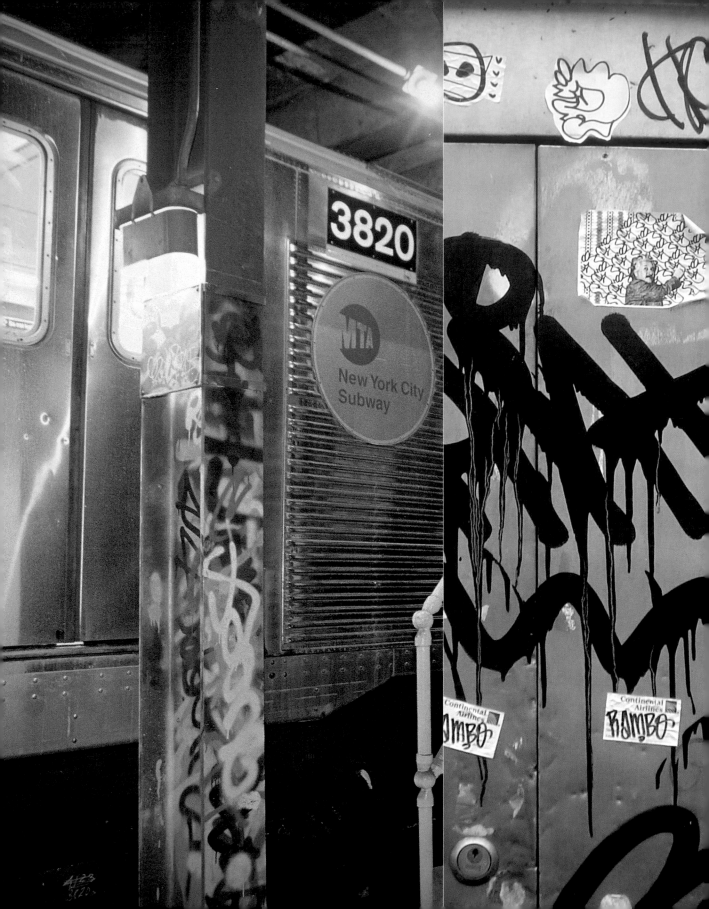

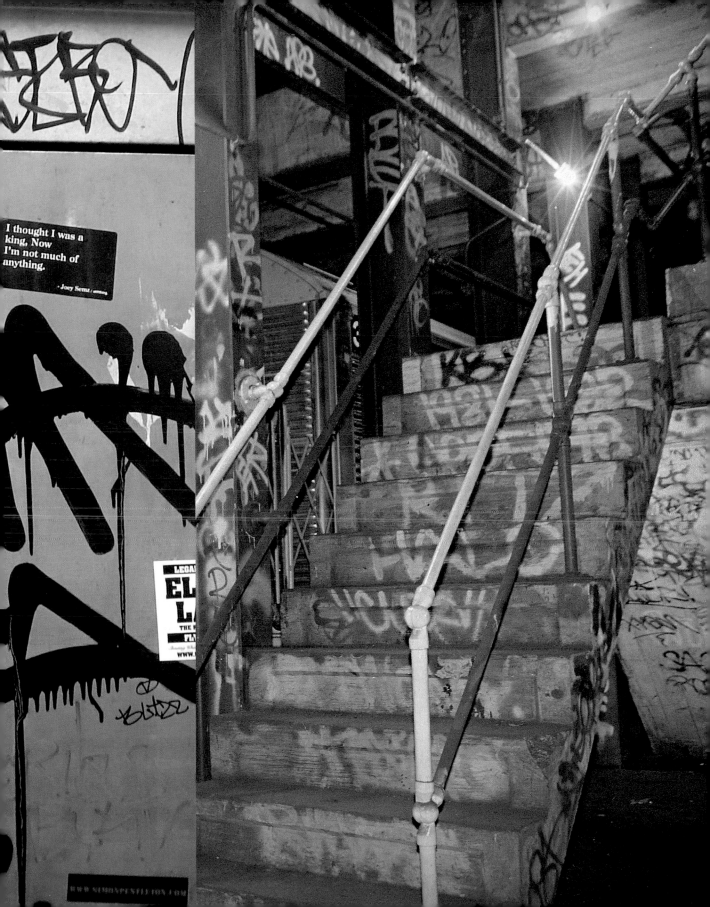

I thought I was a king, Now I'm not much of anything.

- Joey Semz / *untrue*

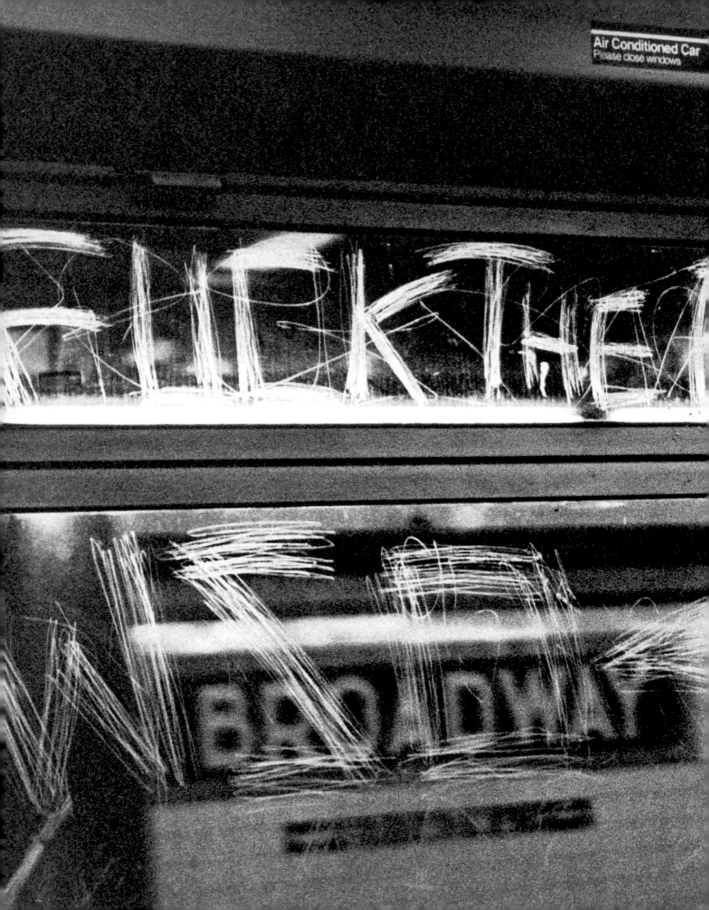

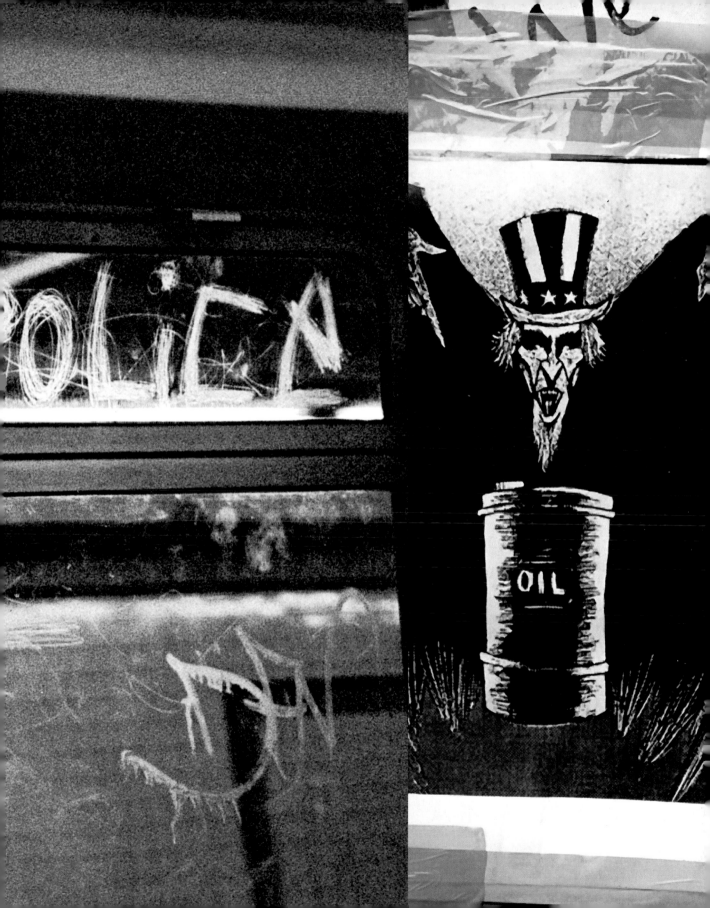

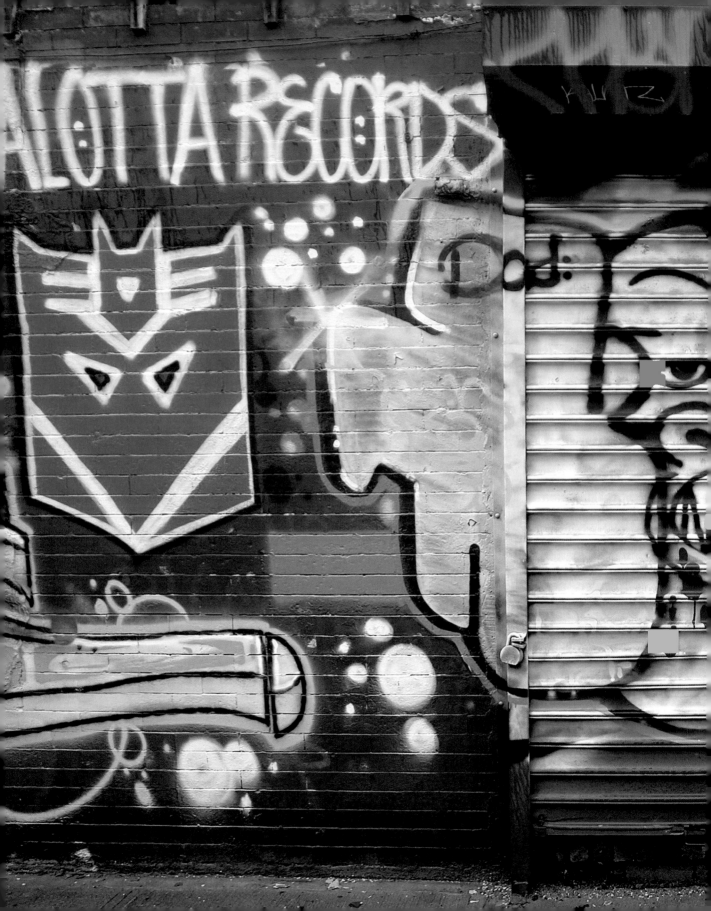

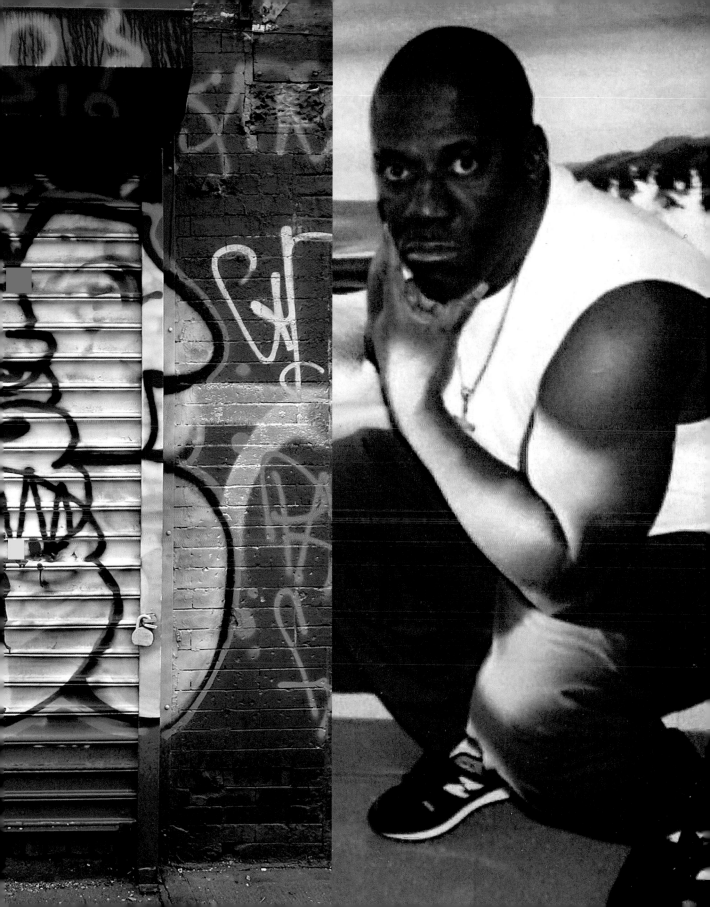

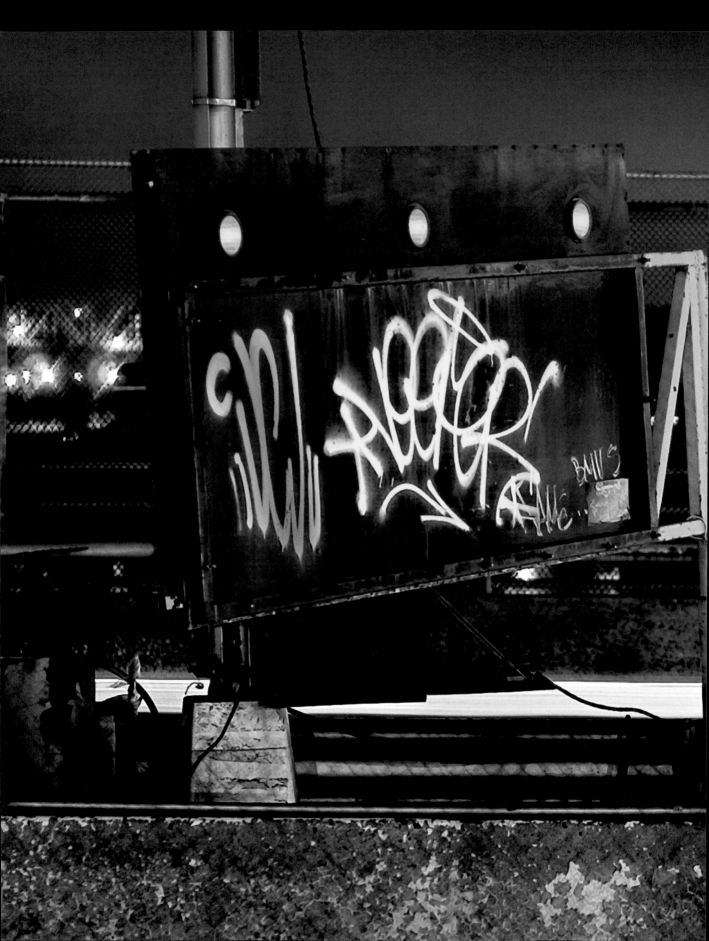

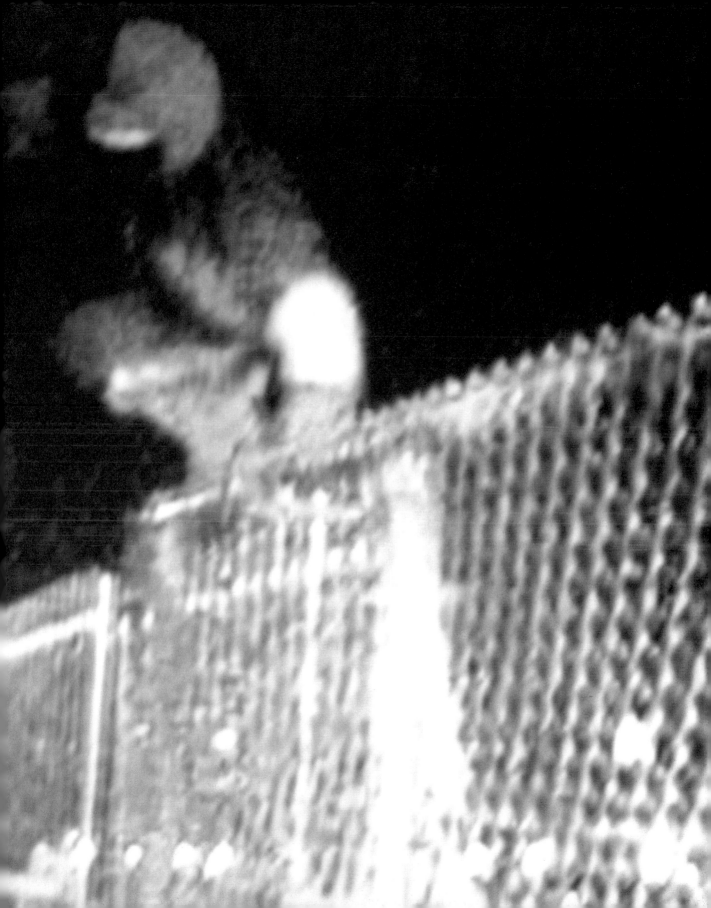

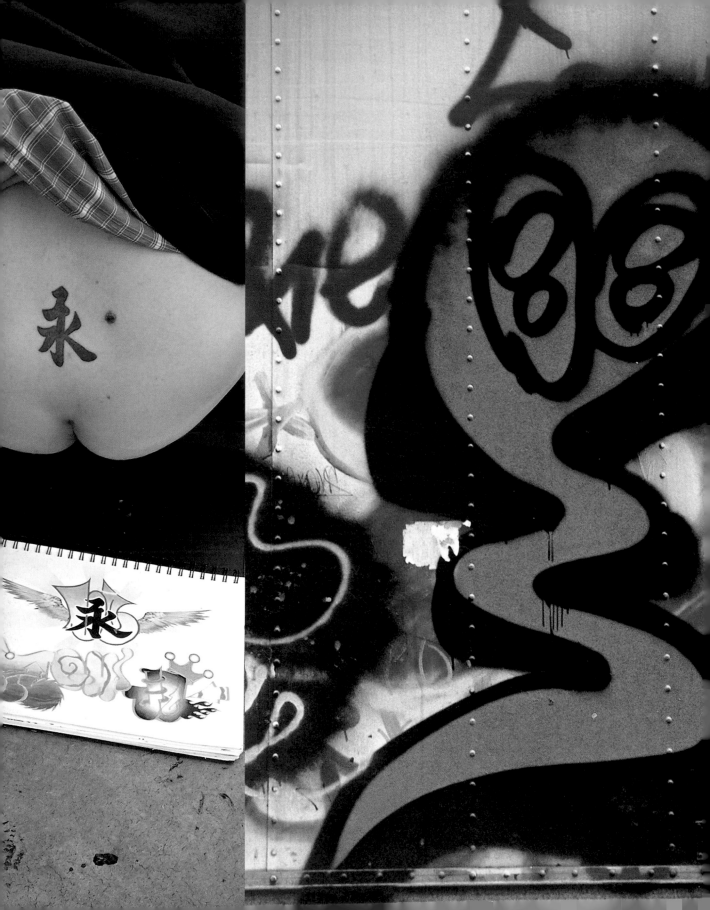

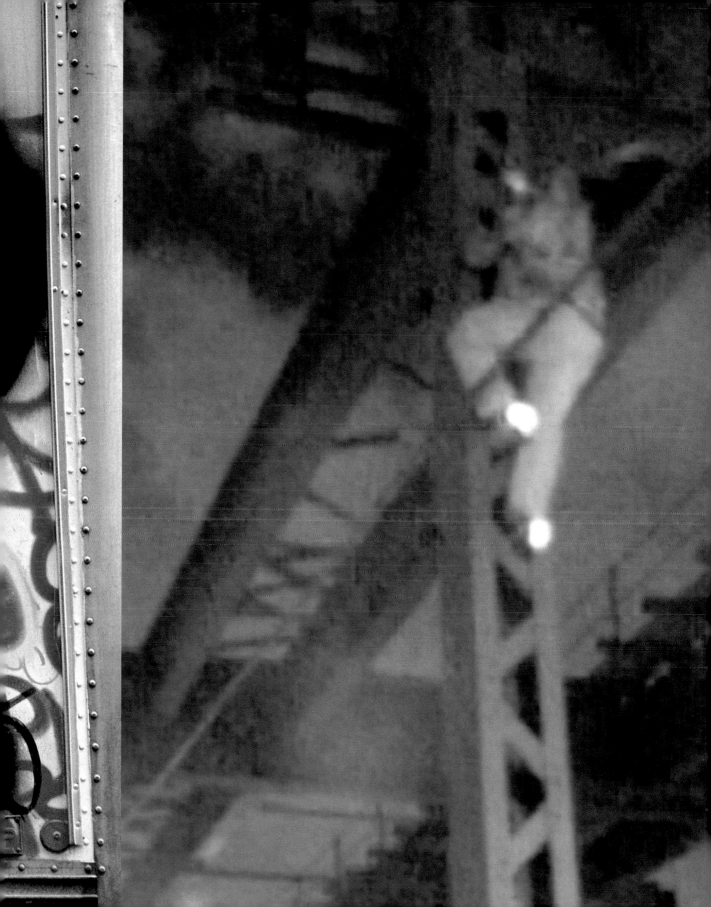

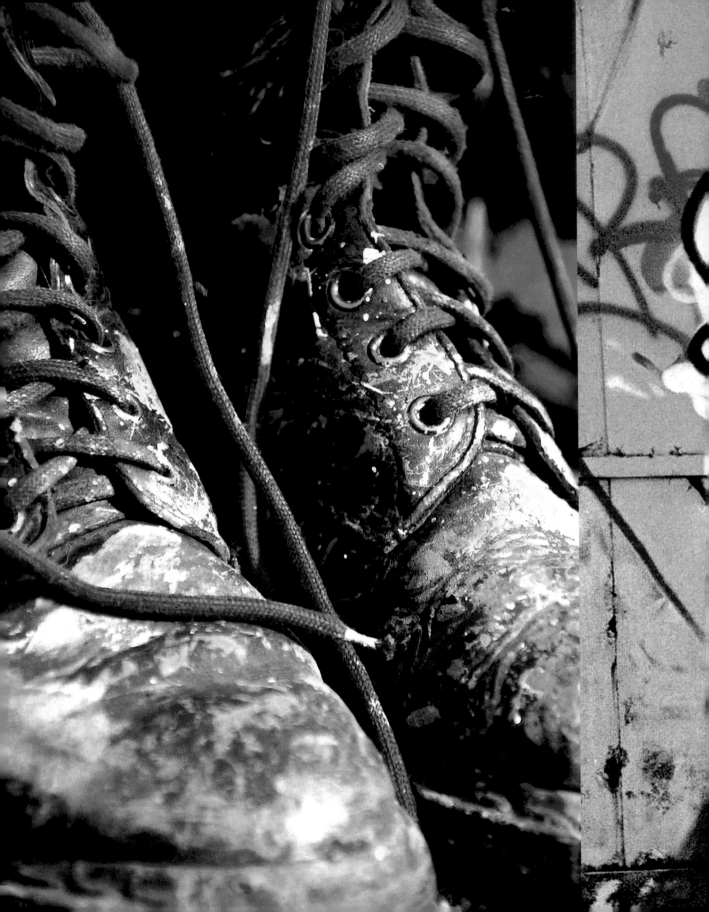

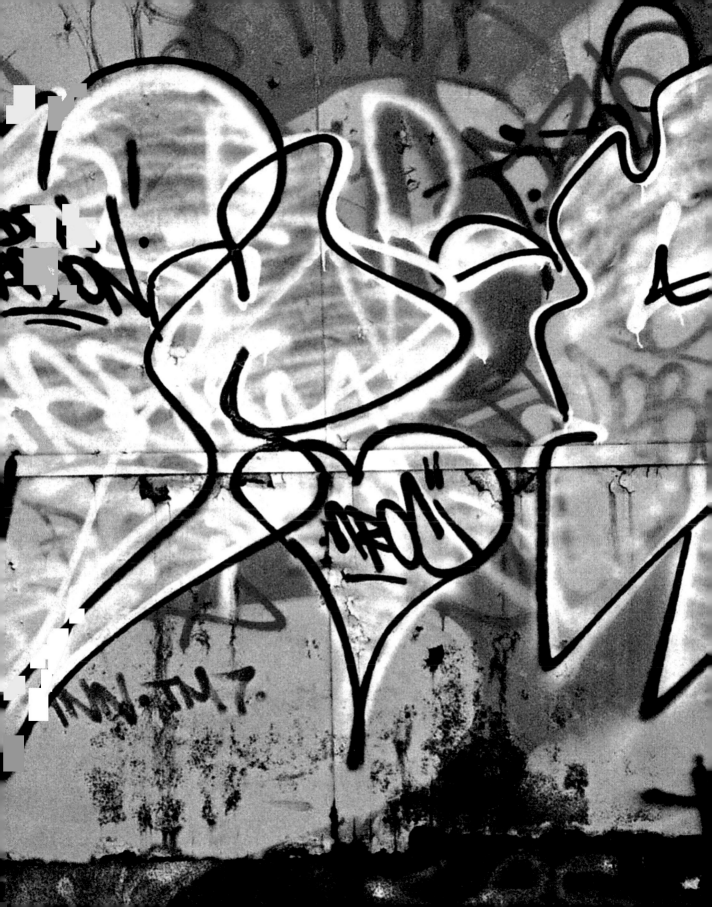

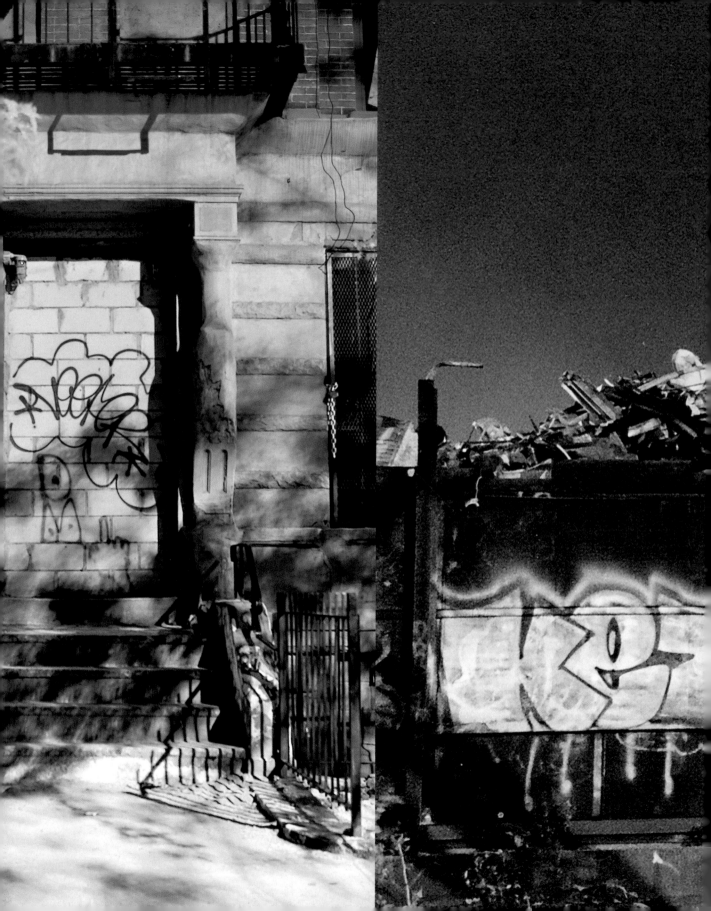

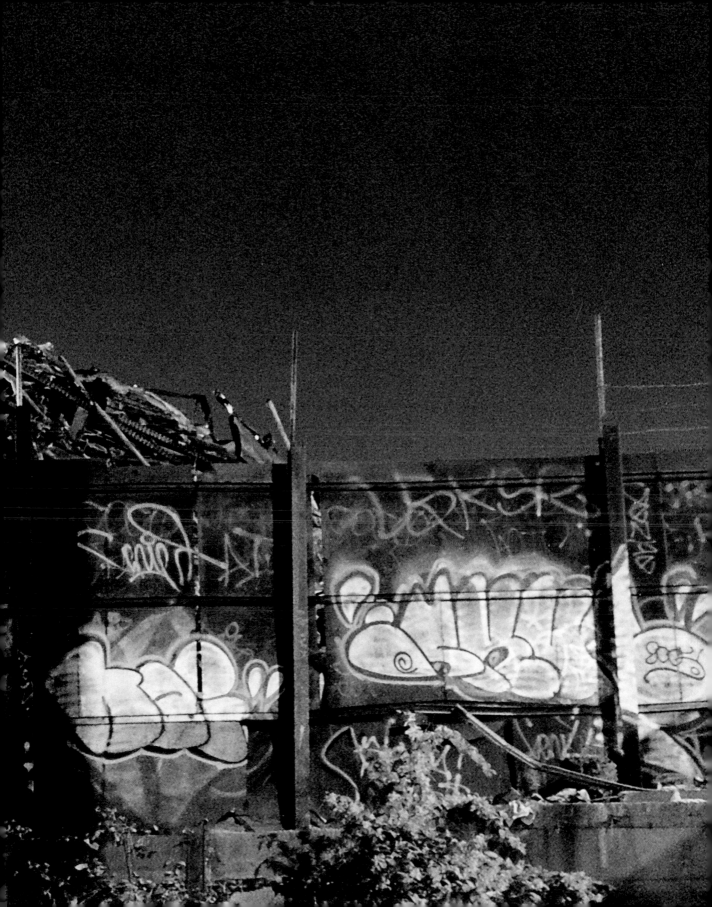

THE BATTLE RAG
TRAIN YARD VANDA
THE GLORY DAYS ARE G
NDERGROUND A STORY IS F
IN A DUSTY PASSAGE WO
ANSWERS TO THE QUEST
OFTEN PONDERS... WHO IS
IS REVS THERE IS R
PEAK

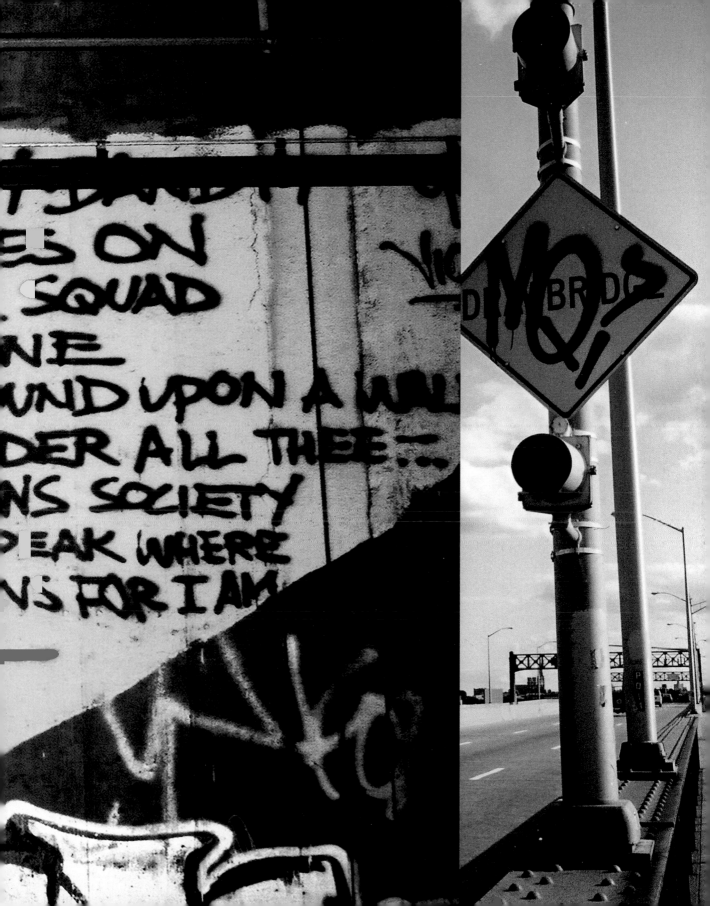

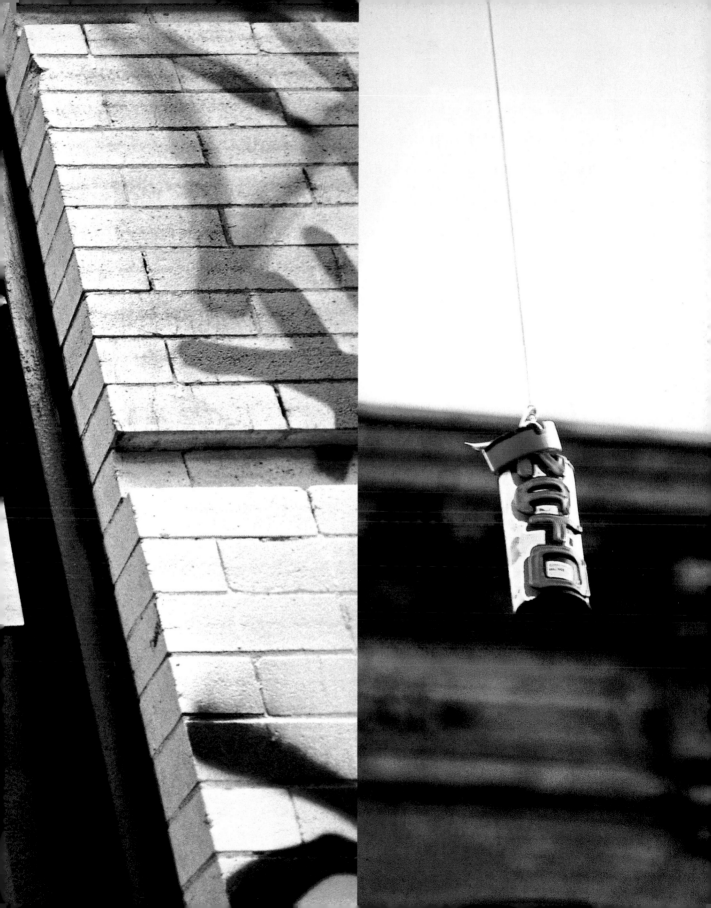

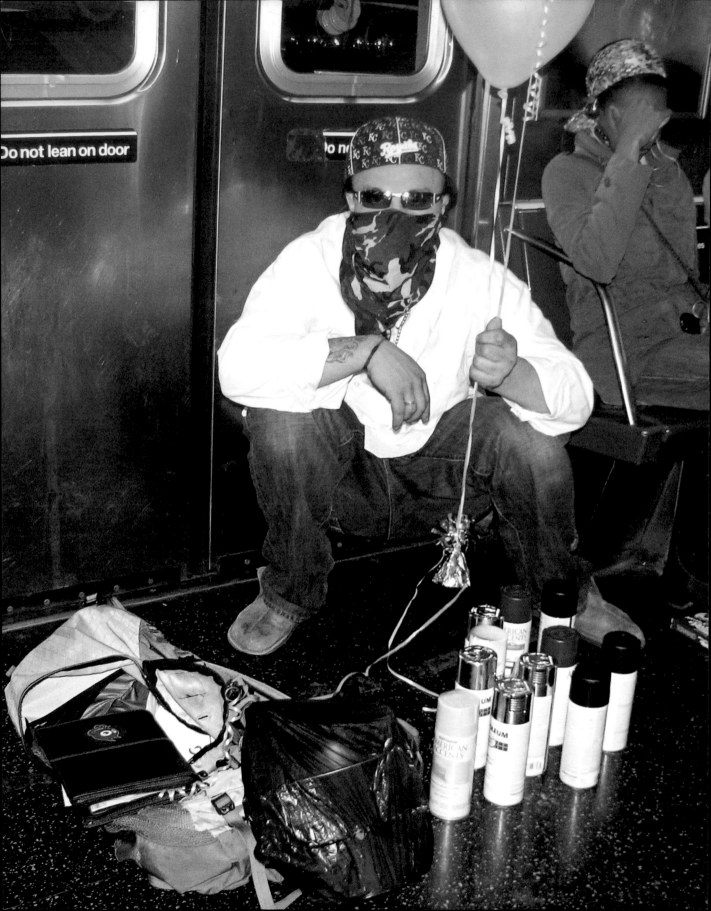

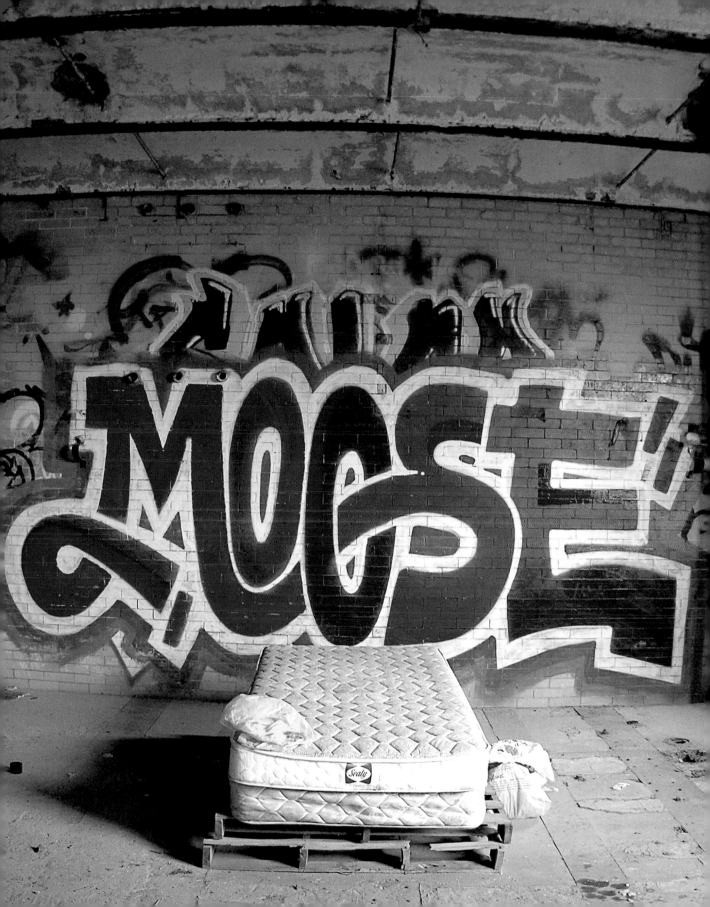

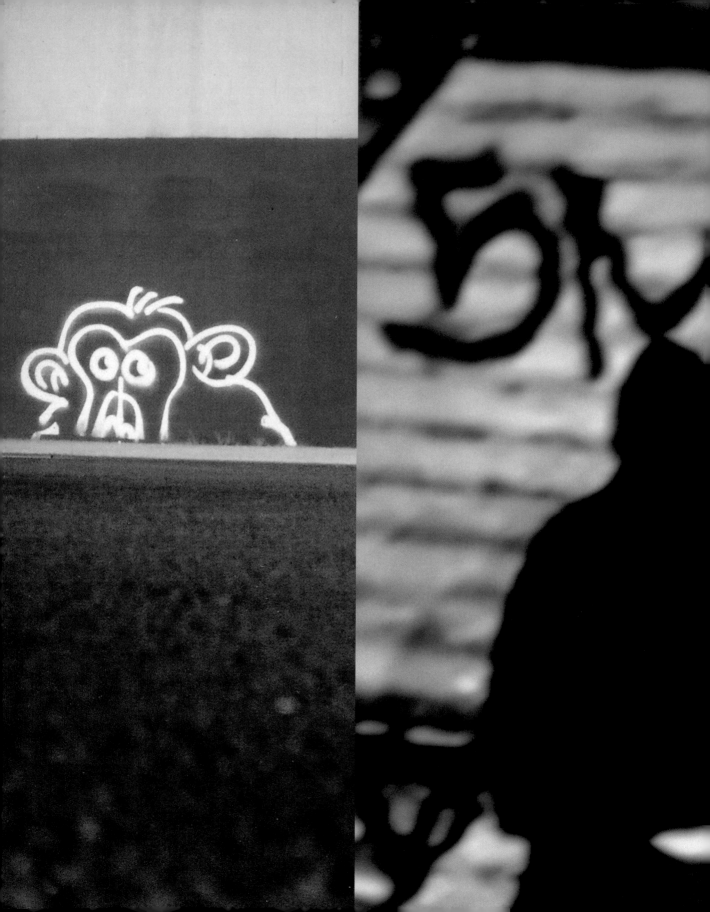

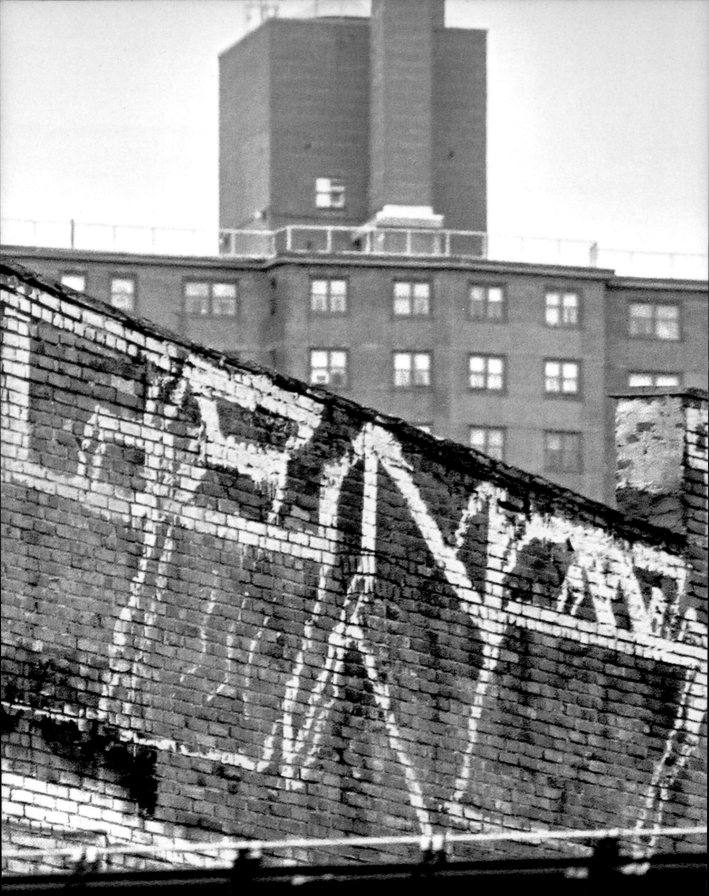

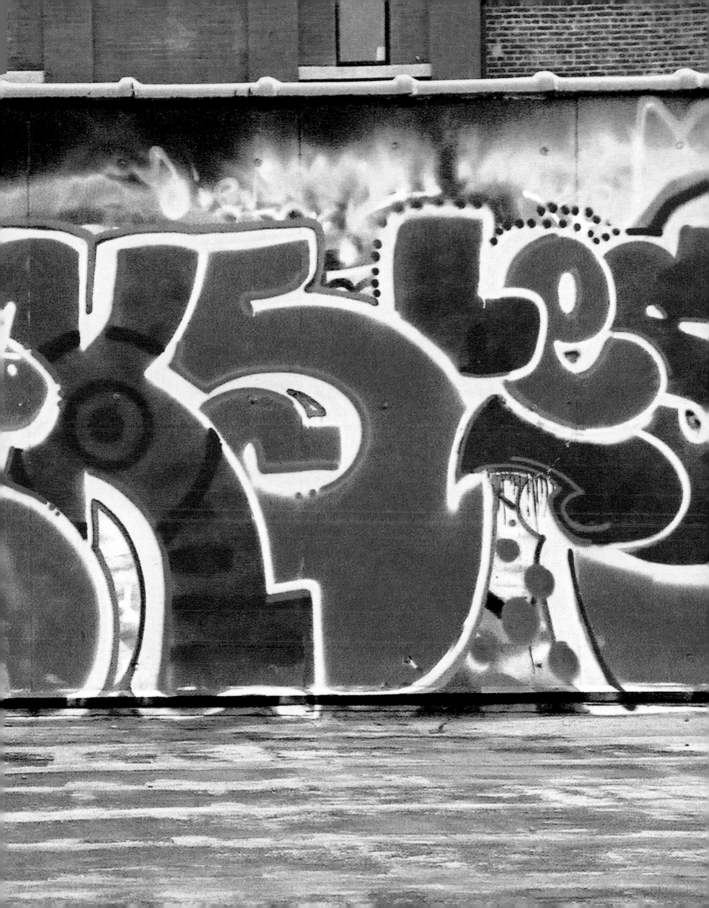

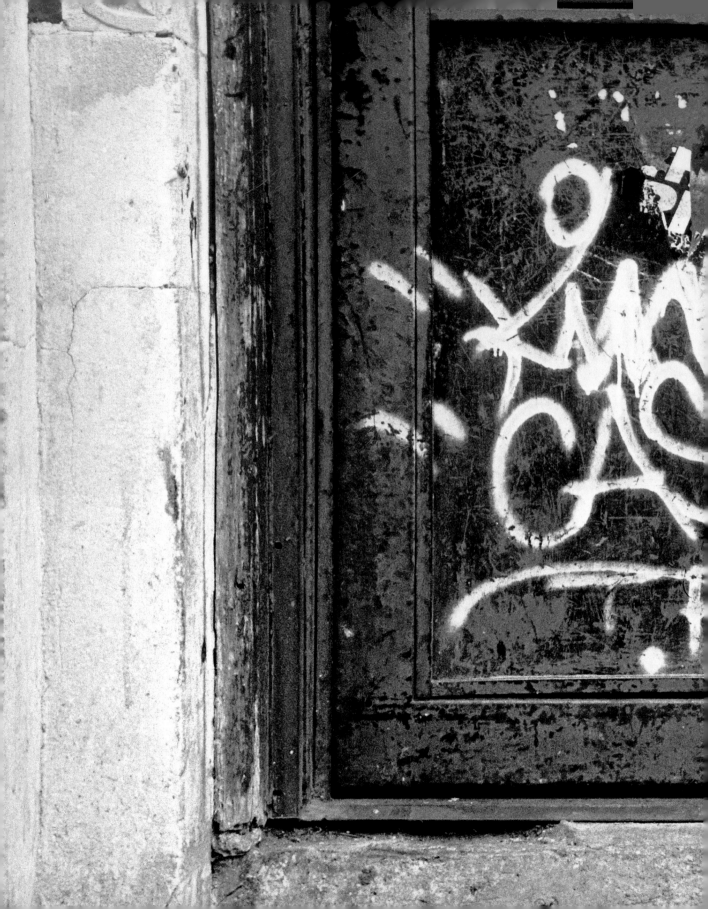

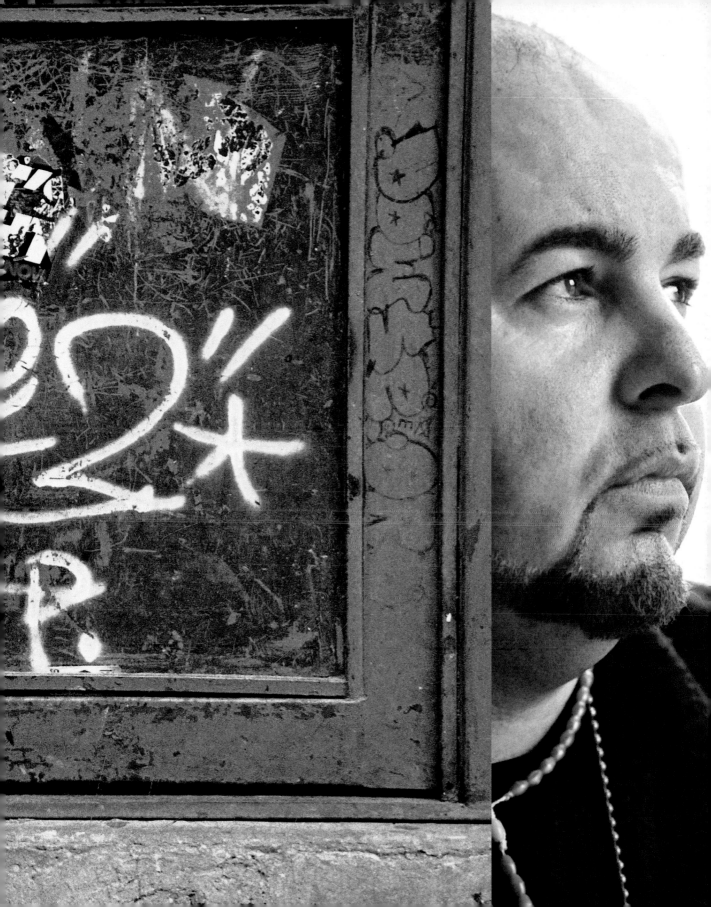

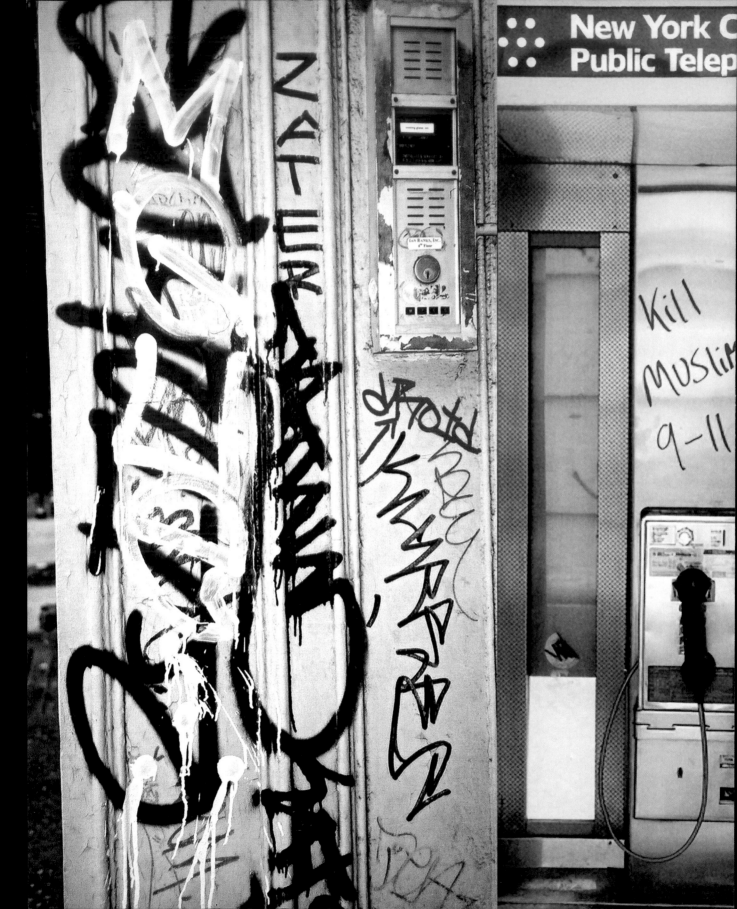

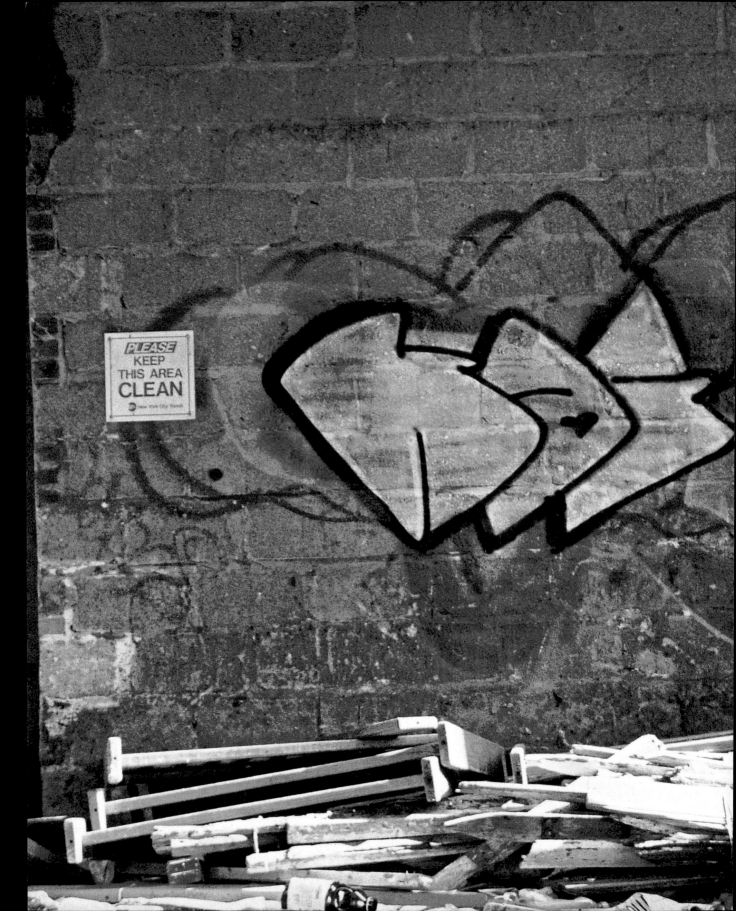

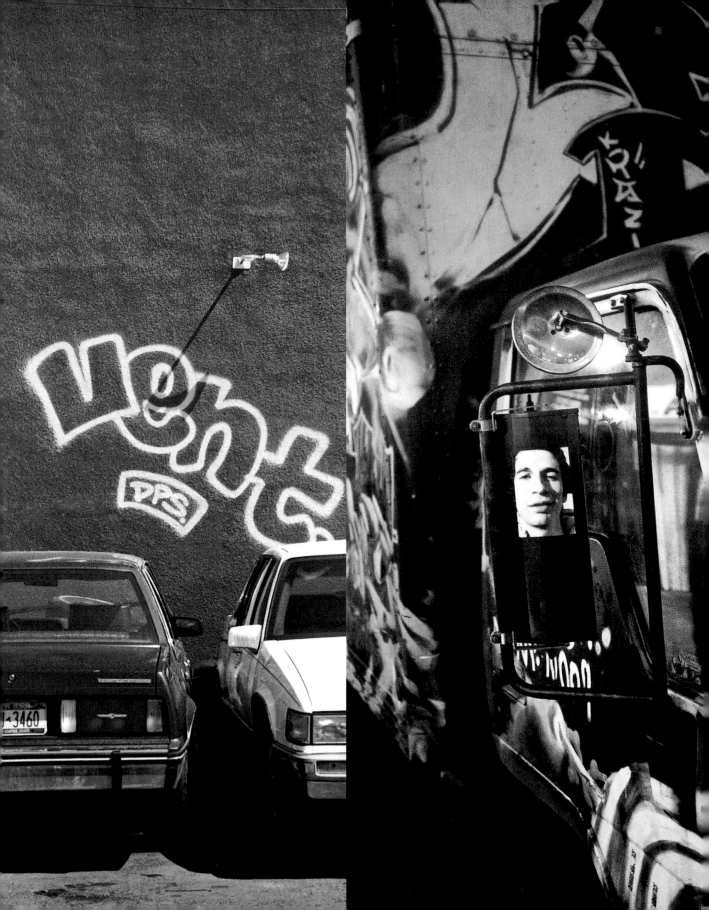

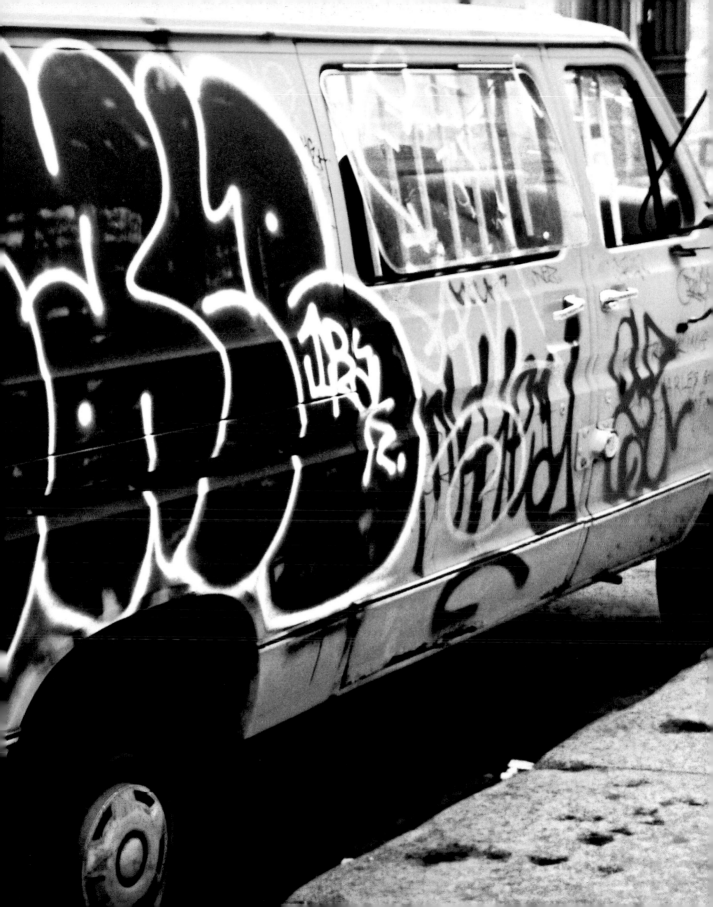

...there it was

...there it was... behind an air vent... a can. I pounced on it... I jammed the can into my underwear and jetted to my crib. My heart was racing... Did anyone know I had it? What was I going to do with it? No... I knew what I was going to do with it... the question was where. NATO

Me and my friends became obsessed with the activity and the culture. The intricacies of it—figuring out what caps to use, figuring out the history of it, who's doing what, what's new, what's old, who to respect, who's a toy, how to go from being a toy to being good—obsessed with getting up. The act of writing is an obsessive act. RATE

I just wanted my name to be verywhere. Every-everywhere. It's almost impossible to be everywhere. Brooklyn alone is humongous. And it's like, in order for you to have your name, in order to be everywhere like that, you pretty much have to... pretty much eat, breathe, shit graffiti. SABE

I don't believe there's any toys, like if you go out and take a risk and get down I respect you. MUK 907

After you kill that first can, you just get all high 'n' shit and you're like, 'fuck it' and just keep going, keep going. SI

If you could bottle the smell of spray paint, like in a perfume bottle, I'd make my wife wear it... I love the smell. Sgt. Robert Barrow, NYPD Graffiti Habitual Offender Suppression Team (GHOST)

I feel good about doing it, like you may work all day and not feel any accomplishment, like you haven't done shit, you've just paid the bills; but, when you come home from painting and you got your flick - that's the feeling. OZE 108

Just smelling the paint, the motion of your arm... it's an addiction. DARKS

It became a meditation for me. Before I knew it I grew up in this neighborhood and graffiti grew up with me. It became part of my life. It became second nature. SKUF

Each letter that I do represents a moment in time, like jazz, it's a feeling. And sometimes when I'm doing it, I'm relieving something that I don't even know that I'm doing, but, when I do it and later when I look at it, I could see that whole fucking moment. Just by looking at the drawing, I could see that whole spirit of that whole day. It's almost like a diary in art. TRACY 168

Trucks are the new subways. KEZ 5

I love it. I love to see my name up. I love bombing, I love it. I like the beef too. NAISHA

I live for art. My whole life is art. Everything I do, live or breathe is art. I pick up the energy of the area, everybody, always.

I write 'cause it's now. U.F.O.

I would pick up the energy of that area. I could feel what's going on in that area. TRACY 168

Overnight I became a fiend without even knowing what was happening. U.F.O.

I would go in the yard at 2 in the morning and leave at 3 in the afternoon. We would get together every day to just talk and plot doing shit. JA

I remember driving on the West Side Highway once with Set and I'm looking up and JA and JD did like 48 or 50 fill-ins in a row on a 25-foot ladder on the side of the highway. Looking at it my jaw dropped, Holy shit! You know how long it takes to do 50 fill-ins on a highway? On a 25 foot ladder! You have to move it every two feet. You have to switch people; meanwhile, the whole time cars are going by. To climb up a 25 foot ladder... it takes a lot of paint. That's bombing, that's something no one could touch. That is King. GIZ

Even if I had a tag on every gate and every rooftop in New York, I still wouldn't be satisfied. For me, Graffiti is a game that never ends. KEZ 5

When you're young, you don't really realize the danger you're putting your behind in. You don't realize that you're dealing with 600 volts of electricity on the third rail—people have gotten killed. You don't realize that you can get busted, and now you have a criminal record. Usually you do those crazy things when you're young. MICO

Death don't matter, it's a part of progress and art is life. Every time I draw, I'm alive. So long as I'm painting, I'm alive. When I stop drawing, then I'll be considered like I'm dying. I try to draw as much as possible. I'm drawing right now, I'm drawing all the time. It's the only time I'm free. TRACY 168

I really started graffiti to substitute it for something else in my life... as soon as I started bombing, like I wasn't depressed anymore... it made me happy. DARKS

I'm like an urban rock climber. I climbed 10 stories between two buildings on a 4-inch pole that ran all the way to the top. When I got to the top, I couldn't even do nothing. I had to find another way up. I didn't get to do nothing that night, but the rush that I got from climbing that shit... I was eight stories up and I went to grab something and like ten pigeons came flying out. 'Whoa, shit!' But you can't let go because you're eight stories up. NETA

If you're a real graffiti writer, you'll always be one. Sometimes you'll stop for a little while and then you'll come back out, but a real graffiti writer will always come back out. That urge is irresistible. GIZ

...the edge

The best thing about graffiti is that it's not supposed to be fuckin' there... OZE 108

The term graffiti is a racist, denigrating term that was applied to our culture, a culture invented by the children of the working class, usually people of color: Black and Puerto Rican, Black and Latinos back in the early '70s, not a culture invented by the children of the rich upper classes, because if it were, the media would never have denigrated the new art form with the term 'graffiti.' They would have named it a 'vanguard pop-art' something. MICO

The issues are simple enough: age, money, culture, and style. Young against old. Hip against dull. Imagination against control. Rebellious urban youth possessed with a sense of élan and sang-froid against elitist politicians whose idea of expression is pinstripes and wingtips. What's so great about whitewashed cement walls and sterile steel subway trains, anyway? The personality of the City is limited to corporate branding. Nothing more. It's everywhere you look —on billboards, sidewalks, buses, subway stations, even garbage cans. They've turned the City into one gigantic advertisement. All bought with corporate dollars, licensed by bureaucrats, and subject to city taxes, processing, and permit fees. Big business forks over millions of dollars to bomb the sides of forty-story buildings with sky-high advertisements. Meanwhile, an army of vice-squad cops march through the streets throwing 16-year-olds in jail for tagging the sides of abandoned warehouses. And what kind of art do corporations commission to push product on teens and young adults? Graffiti!
Dan Perez, Esq.

Me, use that word? Hombre no! [No way, man!] Eso salio después [That came out later]. Eso fue invetao', quizás, por los Americanos o quien sabe, pero nosotros graffiti? Que va pana! [That was invented by the privileged Americans or who knows who, but us graffiti? Nah, bro'!] We used to tag, that's it; we used to hit, that's it. [I would say] 'Yo, Baby Face [Baby Face 86], c'mon let's hit it. Let's tag it, c'mon. Tag, that's it. JOE 182

I can only speak about writing, not graffiti. Writing was what I did back in the '70s. The difference is that writing means writing something—I wrote my name on the walls and on the subways... and graffiti—have you ever looked up the word graffiti in the dictionary? Graffiti means to scrawl, it comes from the Italian graffito. And I've never done one scrawling in my life. MICO

Simultaneously destroying and creating, that's what's beautiful about graffiti. Graffiti is in the moment, and creative and destructive simultaneously. RATE

The presence or absence of signs of disorder in a community can contribute to whether or not other more serious crime occurs. Graffiti vandalism is one of the most visible offenses against the City's quality of life and that is why it is so important to target its reduction. No neighborhood in the City should have to tolerate graffiti. Michael R. Bloomberg, Mayor of the City of New York

These people are not your friends. They will smile in your face and keep talking and try to build your confidence; but they're not your friends. They're getting paid by having you locked-the-fuck-up. SKUF

On my kitchen wall hang four snapshots of graffiti art I saw on construction walls as I walked to my teaching job at Yale University years ago. The declaration, 'The search for love continues even in the face of great odds,' was painted in bright colors... At the time... I was often overwhelmed by grief so profound it seemed as though an immense sea of pain was washing my heart and soul away... The declaration on the construction walls... always lifted my spirits... these works spoke to my heart. Reading them I felt certain that the artist was undergoing a crisis in his life... in my head... I told him how his playful graffiti art anchored me and helped restore my faith in love. Bell Hooks, author, *All About Love*: New Visions (2001)

I'm not an art critic, I'm a cop. I know what a crime is.
Lt. Steve Mona, Commanding Officer, NYPD Citywide Vandals Taskforce

We're not talking here about your paperboy. We're talking about criminals. There's no good excuse for anyone under 21 to be walking around the streets with a can of spray paint. Peter F. Vallone, Jr., NYC Council Member

They should be lockin' up rapists, gangs, drug dealers, real fuckin' crime. Not no graffiti writin' easy shit. SKUF

Graffiti has long been viewed as the most obvious sign of urban blight, and has generated an exaggerated impression of public disorder. This is not about art or the first amendment. There is absolutely no first amendment right to destroy someone else's property. Peter F. Vallone, Jr., NYC Council Member

Lots of people who want to say these are thugs and gangsters don't know what's going on in urban America. Eric Schmeltzer, spokesman for Howard Dean's presidential campaign

Graffiti started as people writing their names on private property with such a systematic and artistic tenacity that it was and still is an attack on our society's value system in which property is valued over human life. RATE

Impurity is the essence of popular culture. So the idea that graffiti changes and is in flux all the time, and the styles, while they have continuity with the task also take advantage of everything new—that's all to the good. I always think of graffiti as being about the moment, and in that sense being a kind of abstract expressionist statement. It's about the self in action. And if you're talking about the self in action, then everything going on around you is part of your work. Richard Goldstein, author

Today, cities are easier to live in, there's less crime, people are kind of softer in general, and all of these things aren't necessarily a bad thing, bit it doesn't help to make solid graffiti writers. RATE

It's a revolutionary statement. You're telling people: You gotta wake up. Bomb or do something. Everything that's out there is aftermath; we need things to compliment. Everything's like a ting-ting-ting-ting-ting. Like a music, a rhythm. *La canción de las paredes, [cantando] 'me lloran las latas de pinturas.'* [The wall song, (singing) 'I got paint cans that jingle-jangle-jingle.'] KEZ 5

You got the landlord who doesn't see the graffiti writers point of view. He just looks at it like they're punks. Thinks we're doing it just to fuck up his property and that's completely not the point. It just happens that his property is our canvas. GIZ

The only time graffiti feels bad is when you're sitting in the back of a paddy wagon handcuffed. DARKS

We understand that low-level, highly visible crime often breeds more serious crime. So I initiated the Anti-Graffiti Vandal Squad as a specialized unit within the New York City Police Department. Last year, the Vandal Squad made nearly 190 felony arrests and nearly 1,300 misdemeanor arrests. Thanks to their efforts—and yours—our parks are now nearly graffiti-free, with 97 percent of parks rated acceptable for graffiti. Rudolph Giuliani, former mayor, City of New York

Graffiti is a gateway crime that both leads children and adolescents astray and sends a message that a graffiti-covered neighborhood is ripe for criminal activity. Peter F. Vallone, Jr., NYC Council Member

The City could take an enlightened view of graffiti, and reach out to these people, meet them, and see if there's a way that they can help them to channel what they've considered to be anti-social behavior into acceptable social channels. Honorable John Carro, Retired Justice of the Appellate Division of the Supreme Court of the State of New York

Anything that legitimizes graffiti probably cancels out the part that makes it actually graffiti. Because graffiti is illegal, and if it's a legal venue, then it ceases to be graffiti. RATE

If they make graf legal, I'll stop. NOXER

Graffiti writers are cultural imperialists. Their message is always the same: I live in a slum and so do you. Graffiti writers are trying to do away with the variety of urban life and replace it with their own harsh culture.
George Jochnowitz, professor emeritus of linguistics, College of Staten Island, CUNY

A stupid writer is gonna just write on anything. A smart writer is going to write on the best spot, regardless of what it is. Something that people look at and say, How the fuck did he get away with that? Basically, they scratch their heads and say, How did he not get arrested doing that? or, How did he get up there? GIZ

Someone like SKUF or JA— has a really ghetto element to what they're doing, like, 'I don't give a fuck' and that's what graffiti is about. You're almost scared to look at it, it's so balls-out, what they're doing. EARSNOT

It's a cosmetic crime. They associate graffiti with violence and negative shit. If they clean up this cosmetic act, New York City is a peaceful place—but it's not. Motherfuckers be getting killed every day, but they don't care as long as the walls are clean. SKUF

In America there seems to be no distinction between big crimes and small crimes. MARIA DEL MONACO, Italian tourist arrested for defacing a public work by Christo

If my son got arrested for graffiti, I would be proud of him for being a rebel. Lt. Steve Mona, Commanding Officer, NYPD Citywide Vandals Taskforce

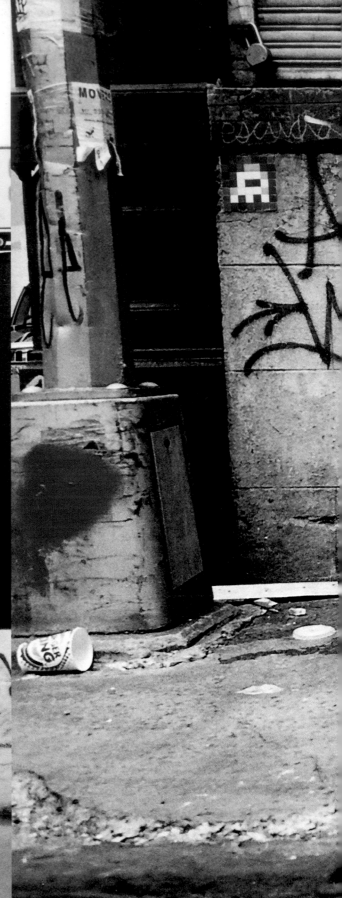

THE HENLEY CO' RARY

METRO AUTO
714 386-3032

METRO
AUTO
SALVAGE
FOREIGN
CAR SPECIALISTS
381-9090

AUTO
GLASS
FOREIGN & DOMESTIC
ALL MAKES & MODELS
628-0698

B & C
INDUSTRIES

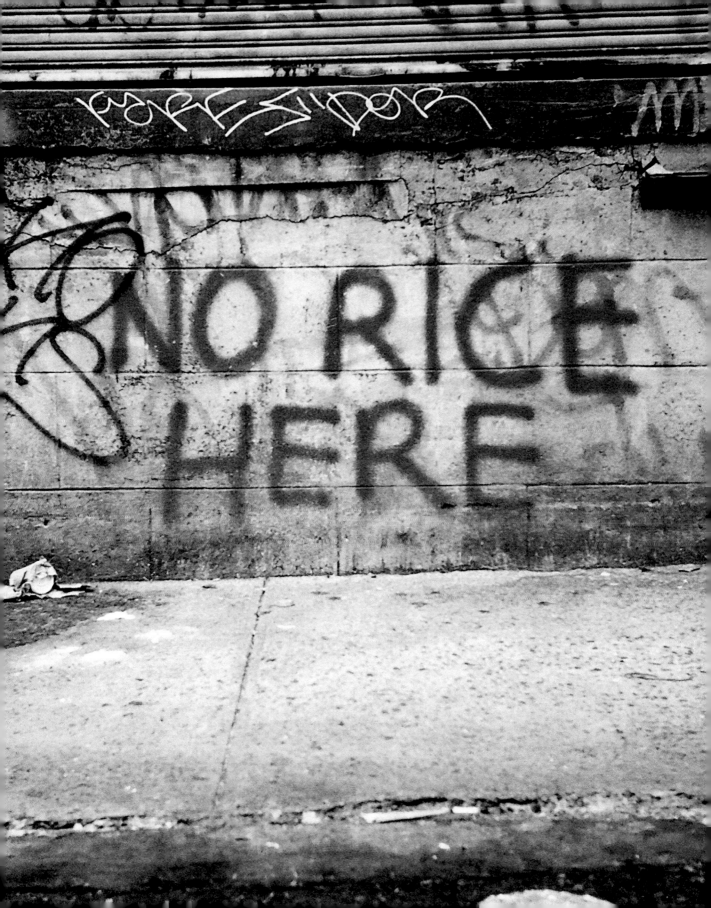

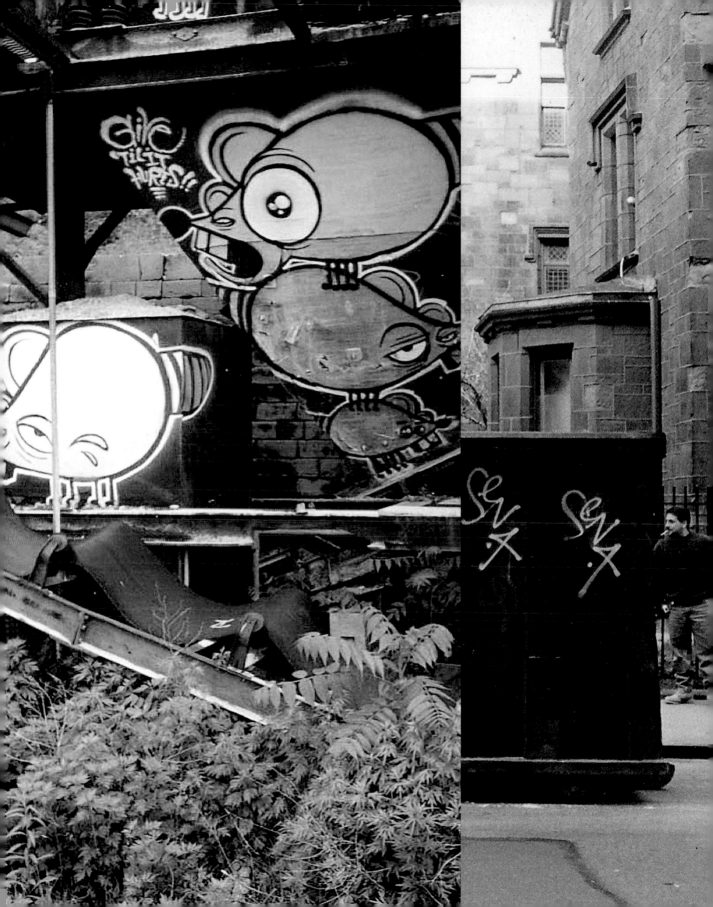

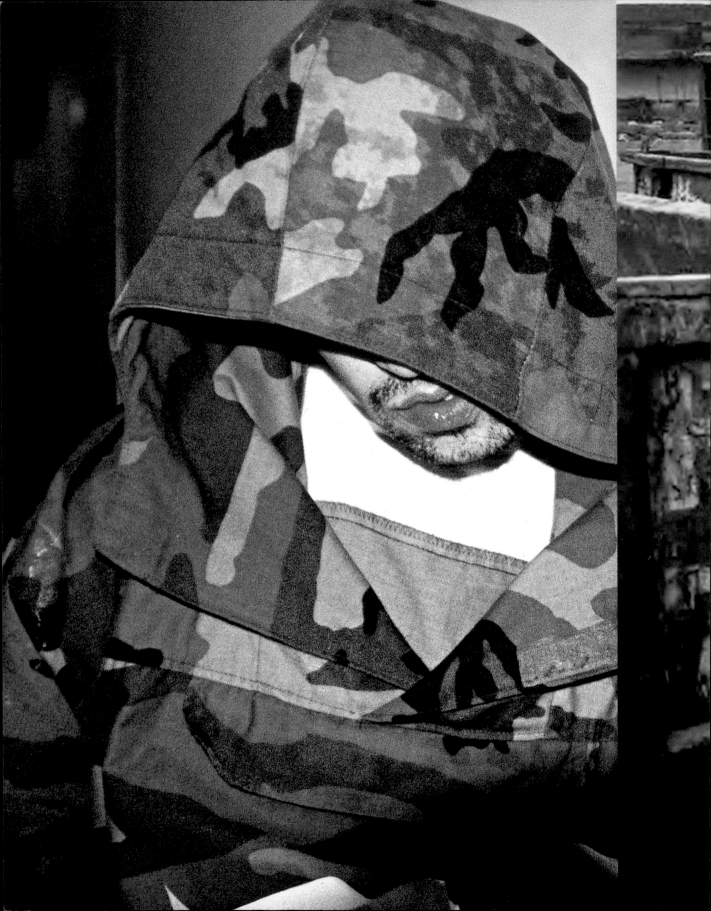

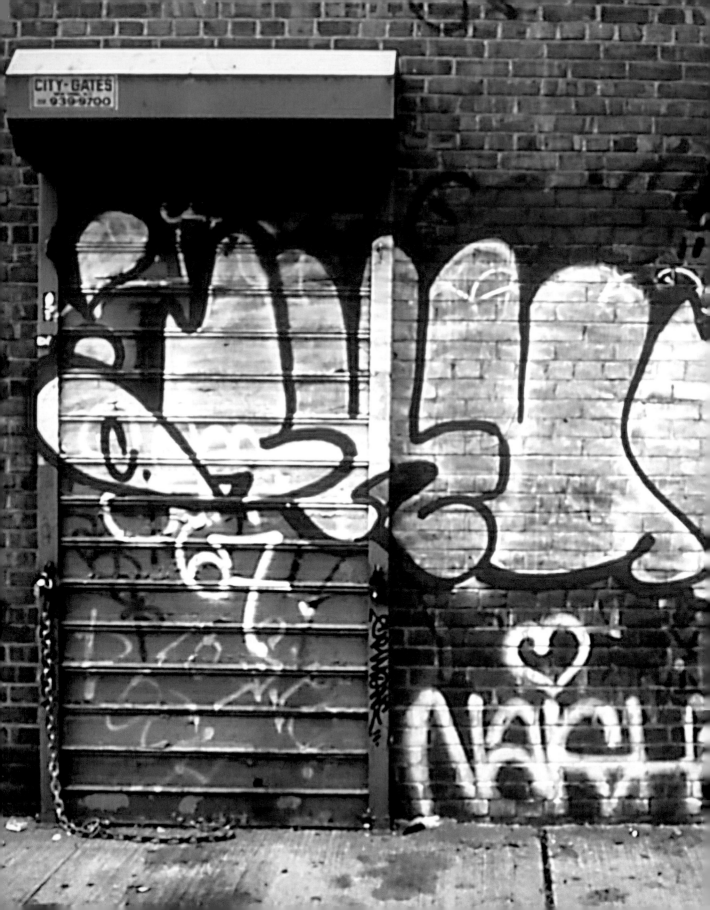

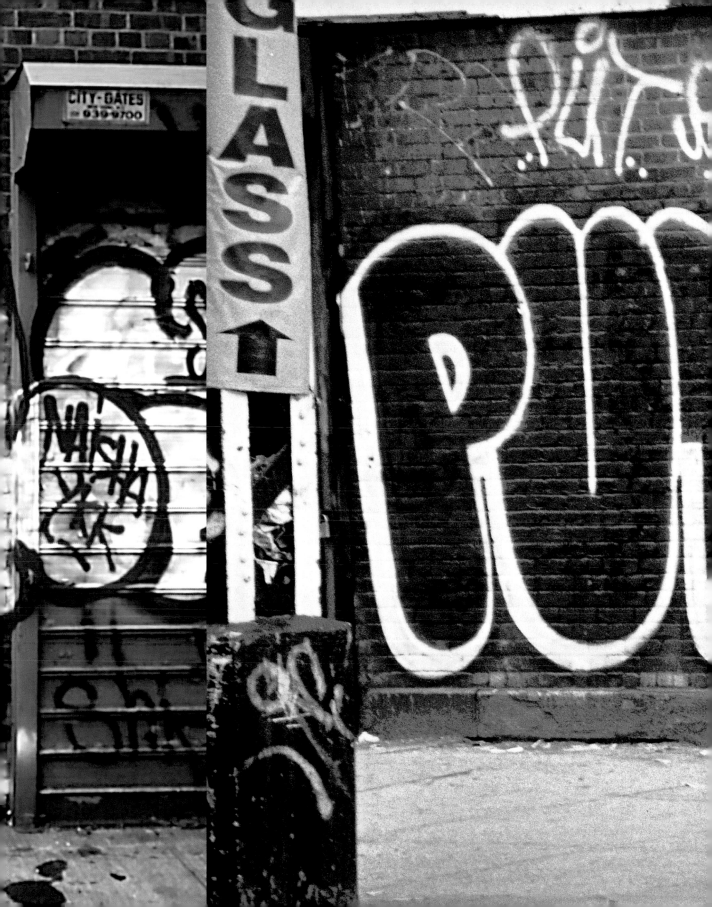

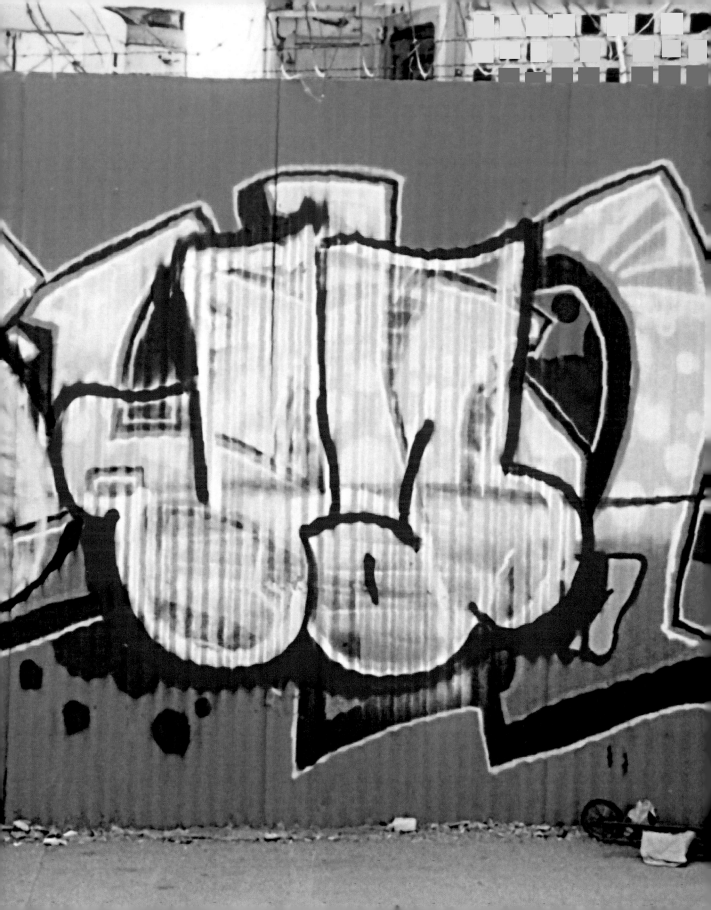

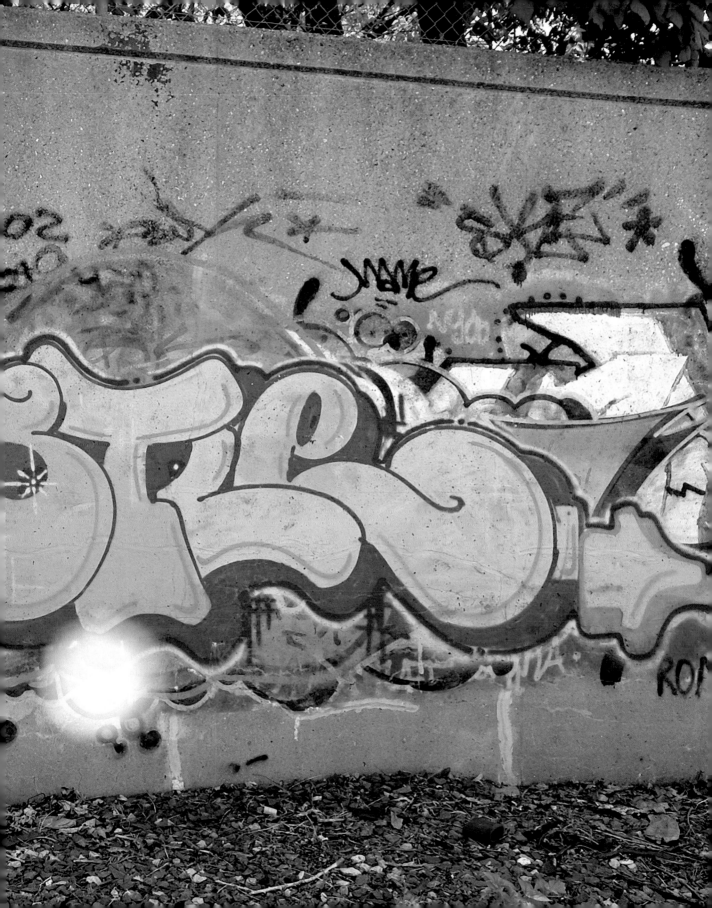

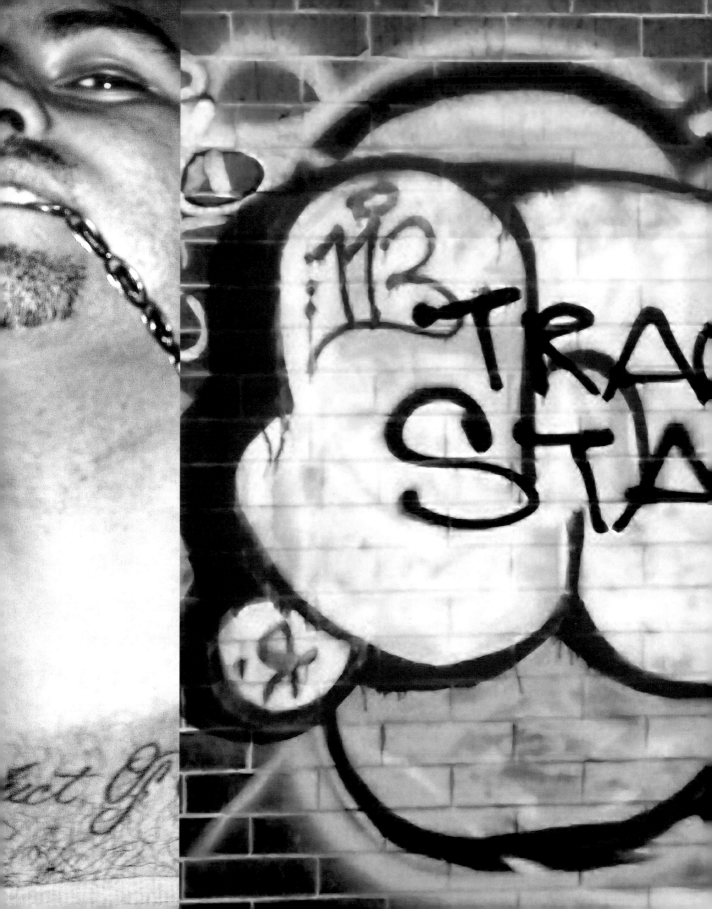

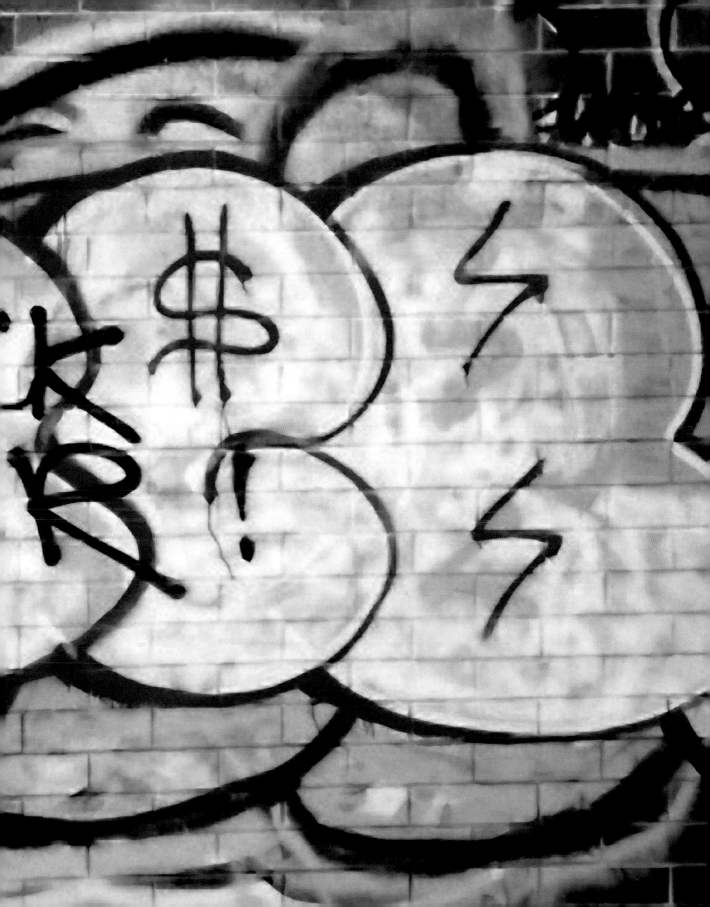

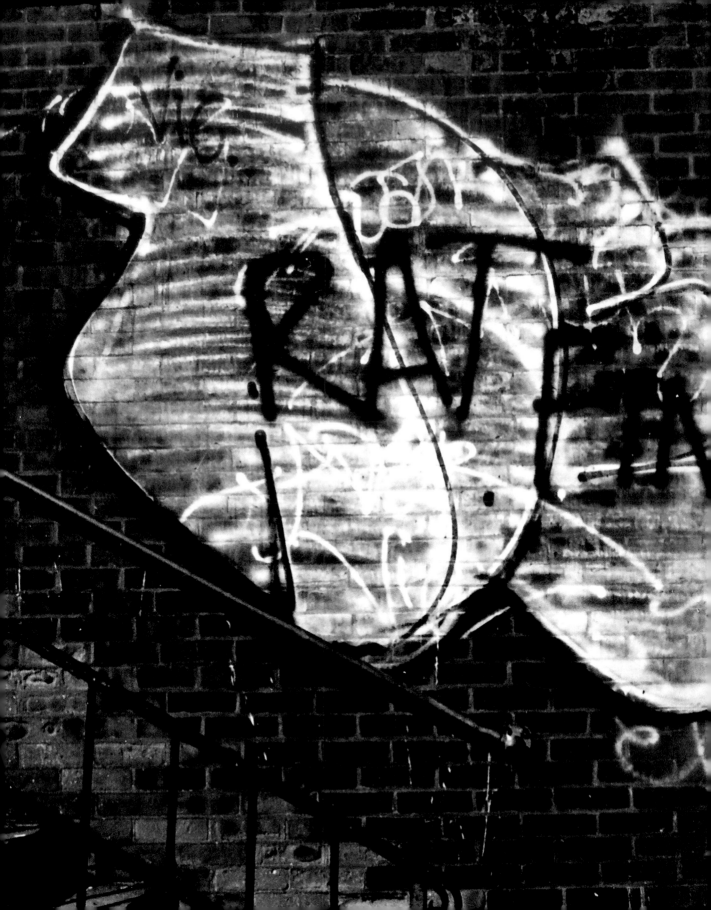

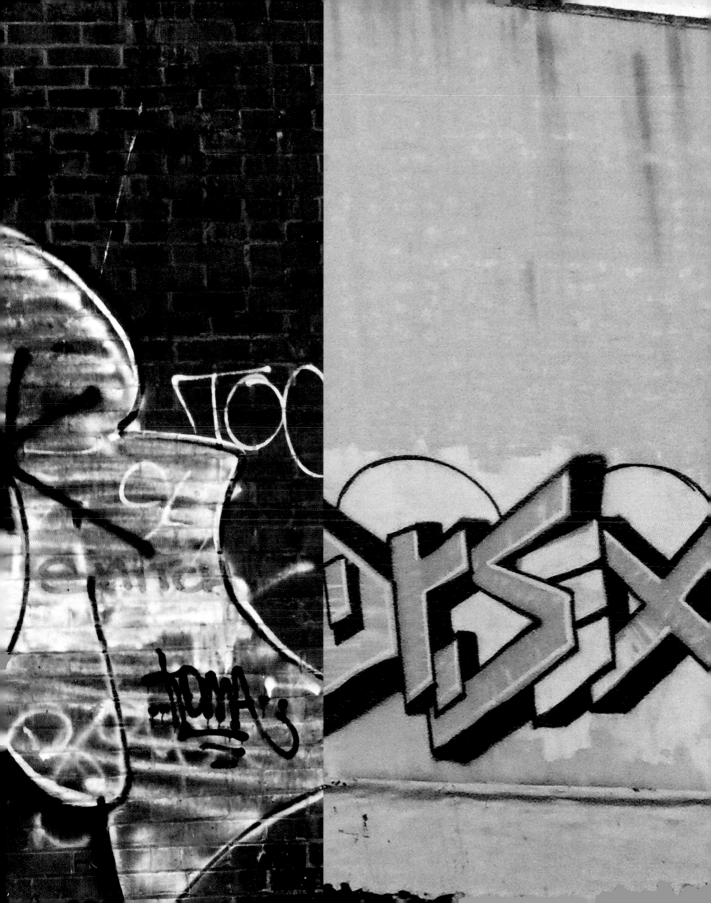

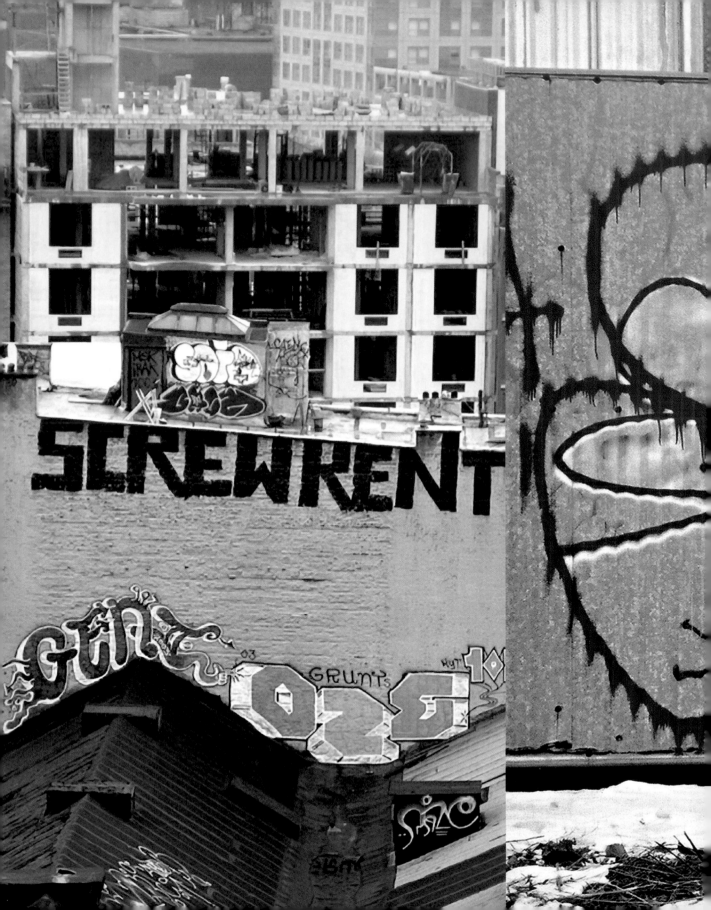

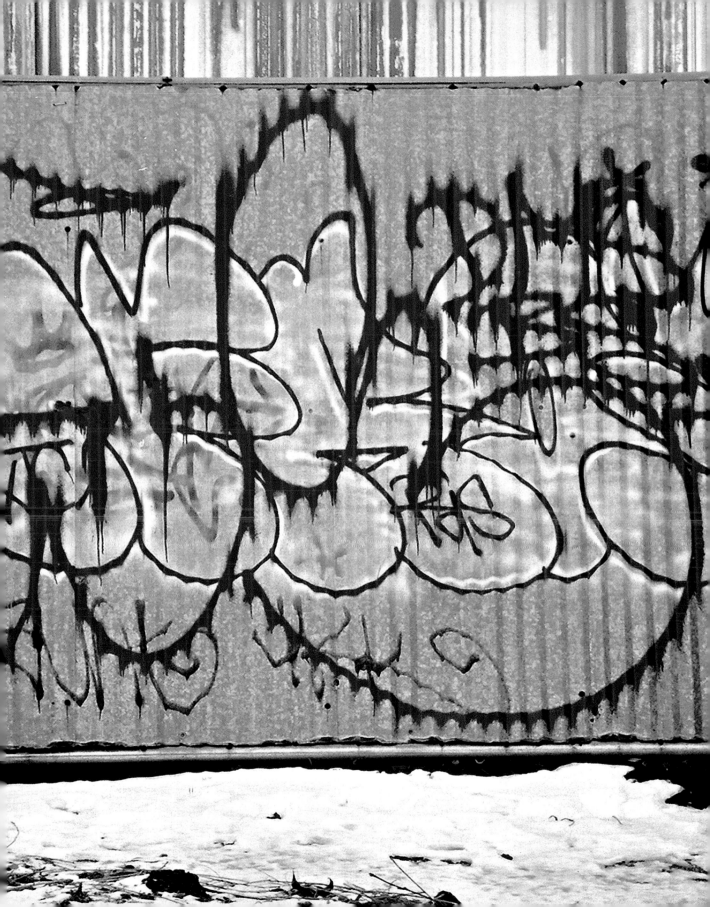

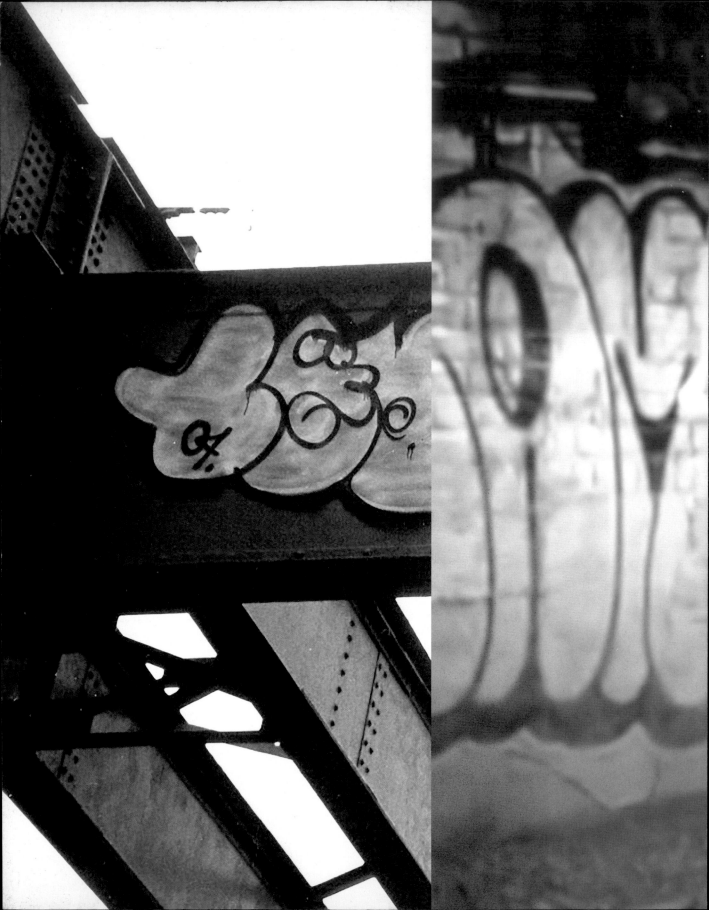

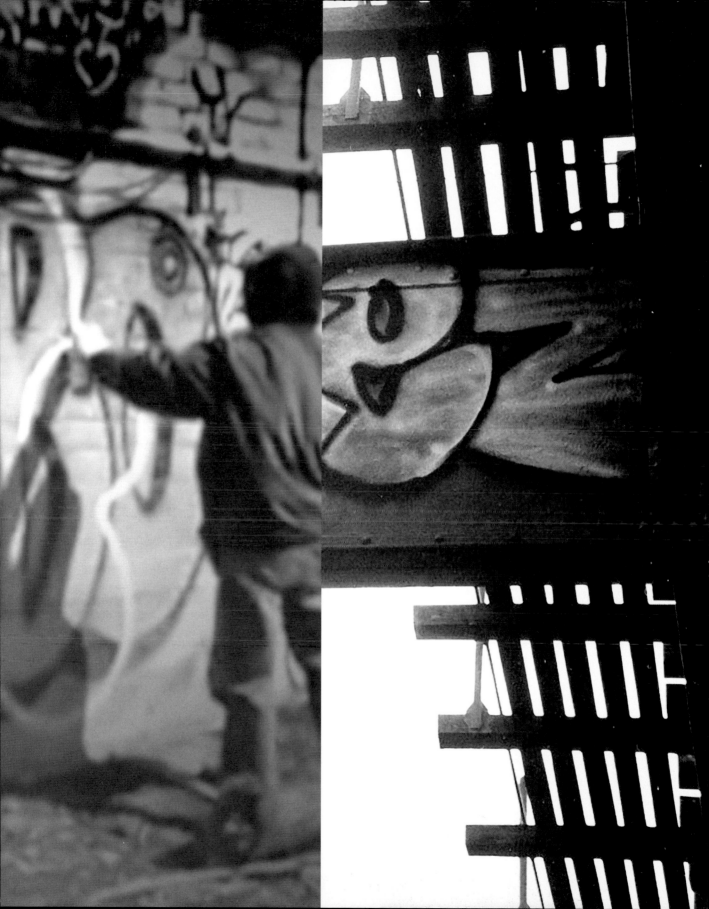

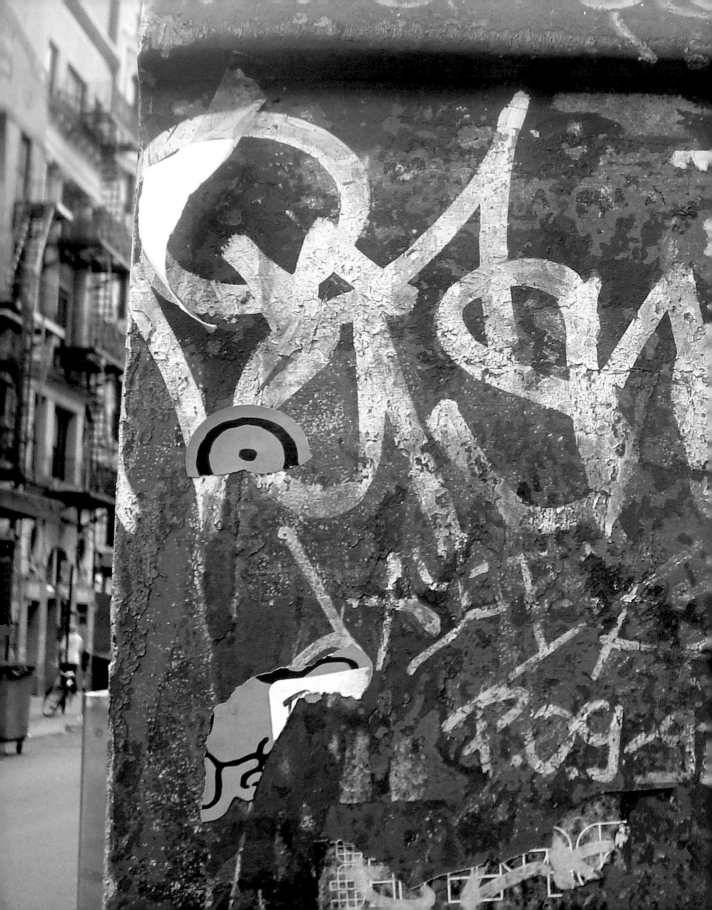

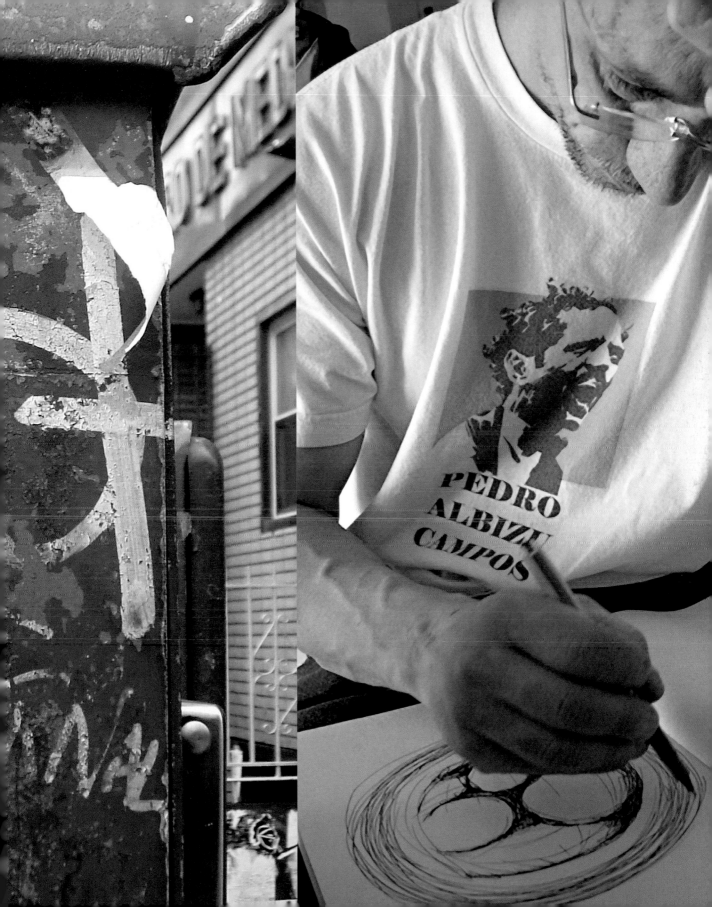

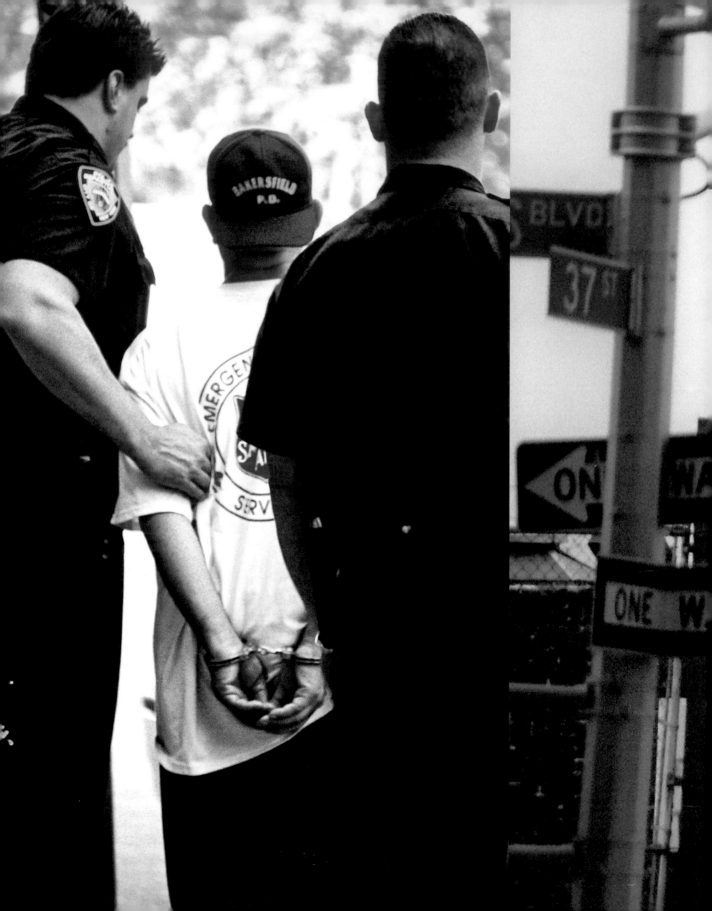

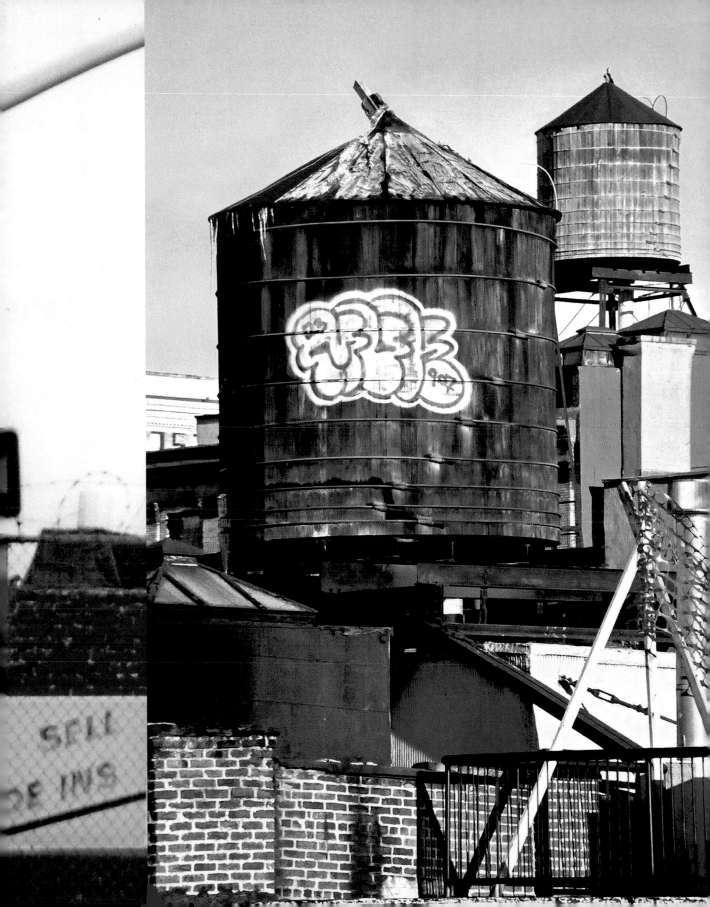

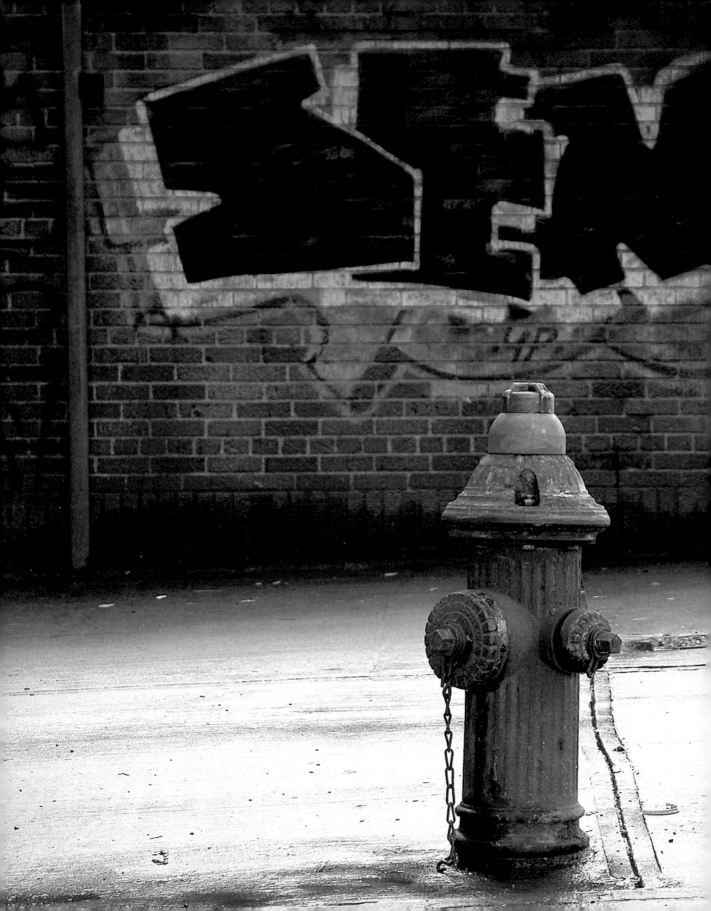

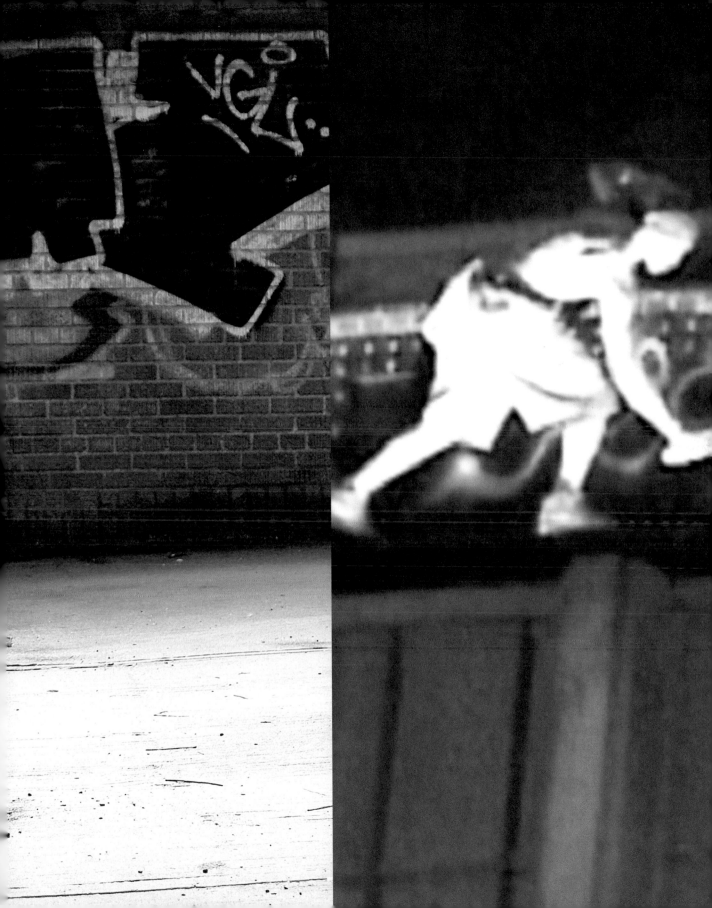

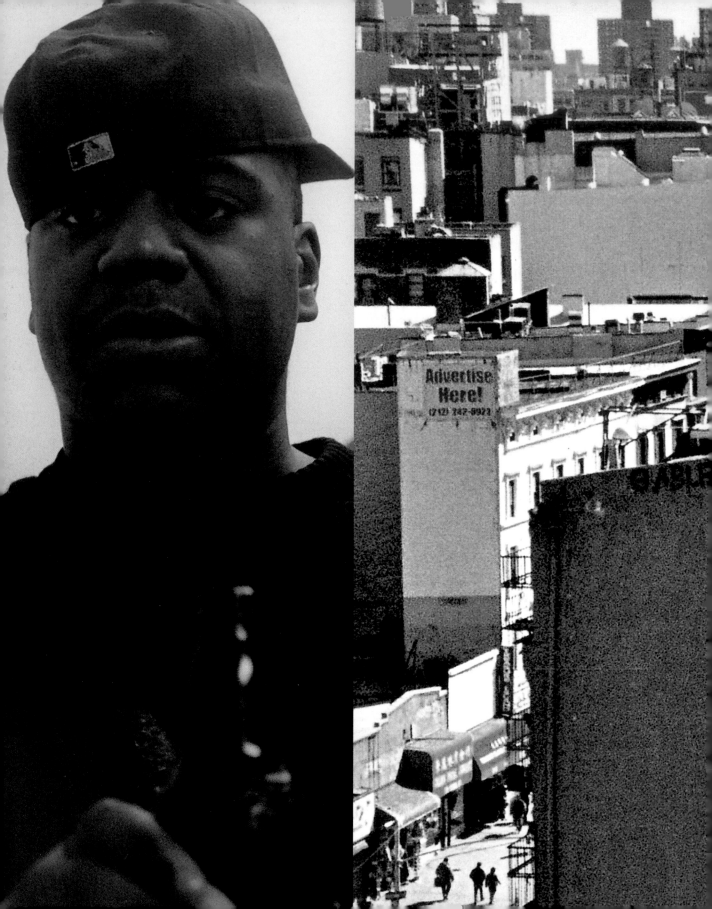

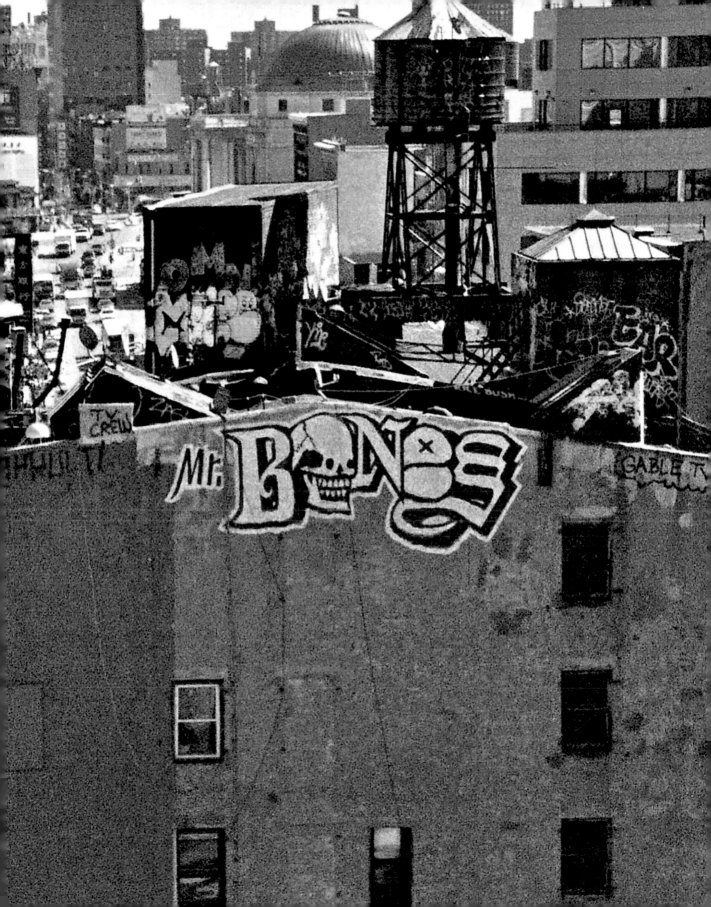

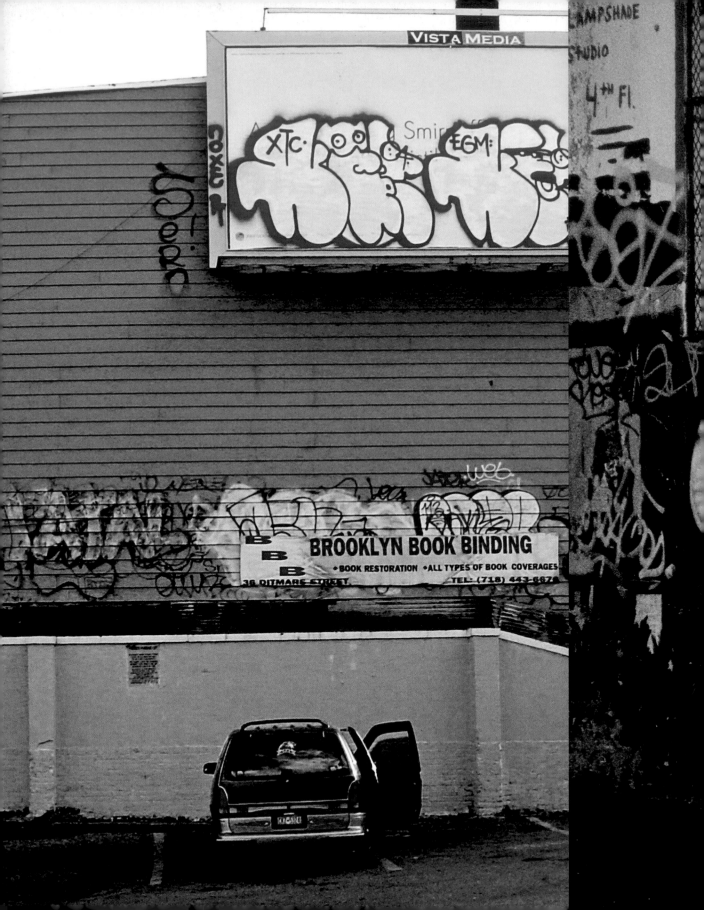

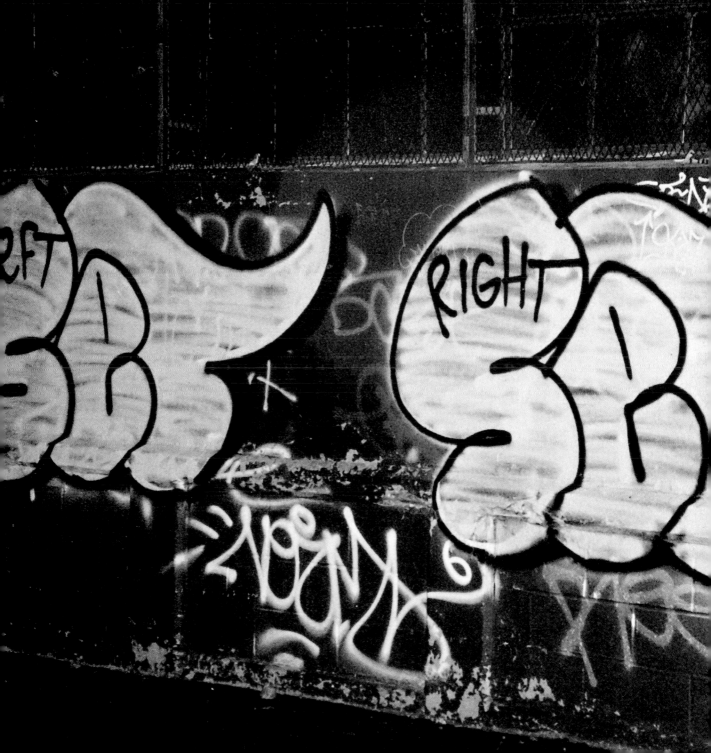

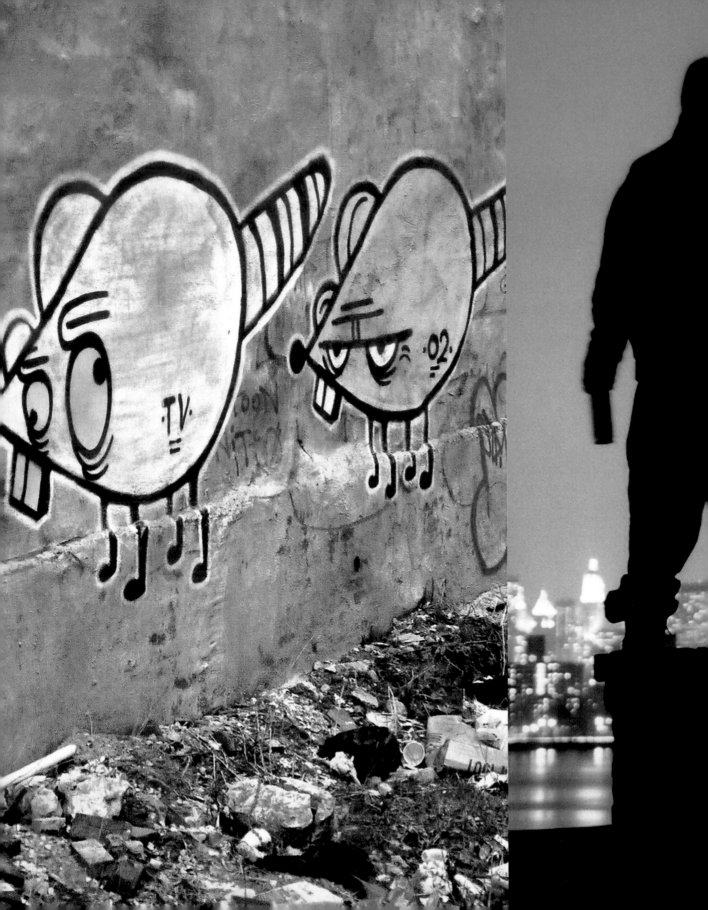

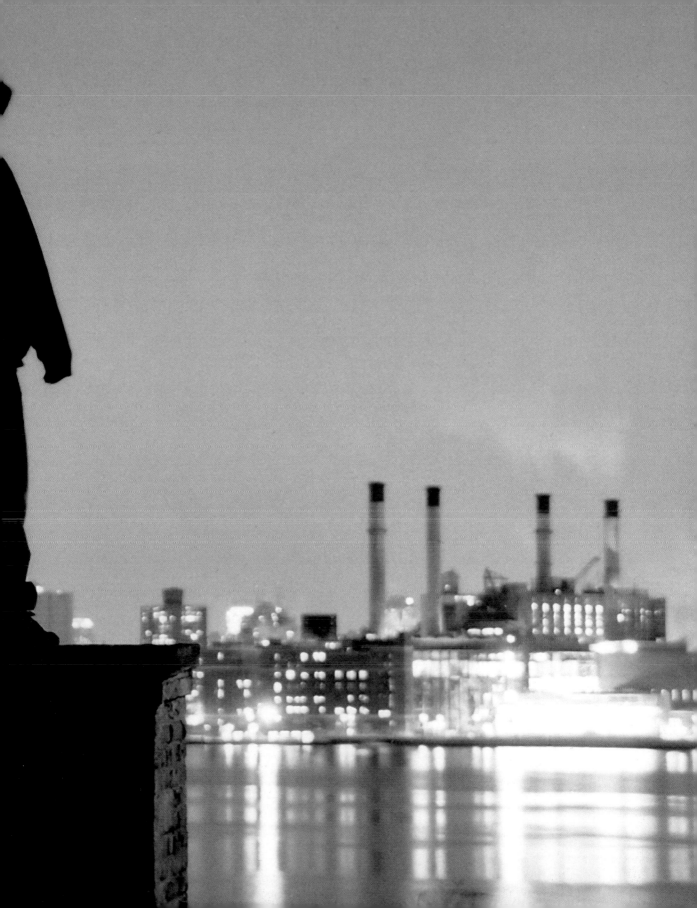

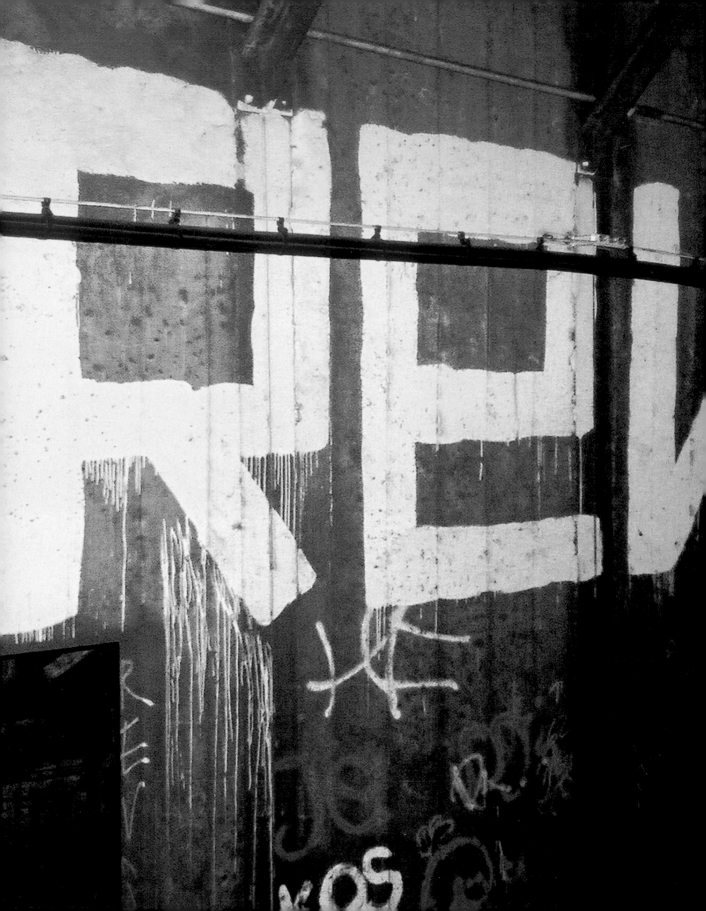

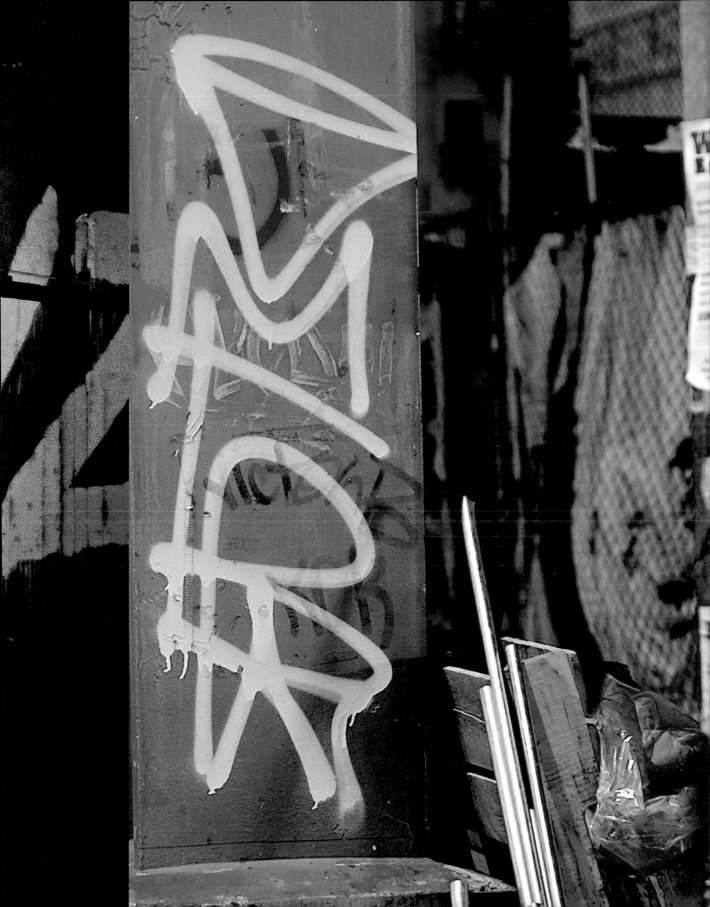

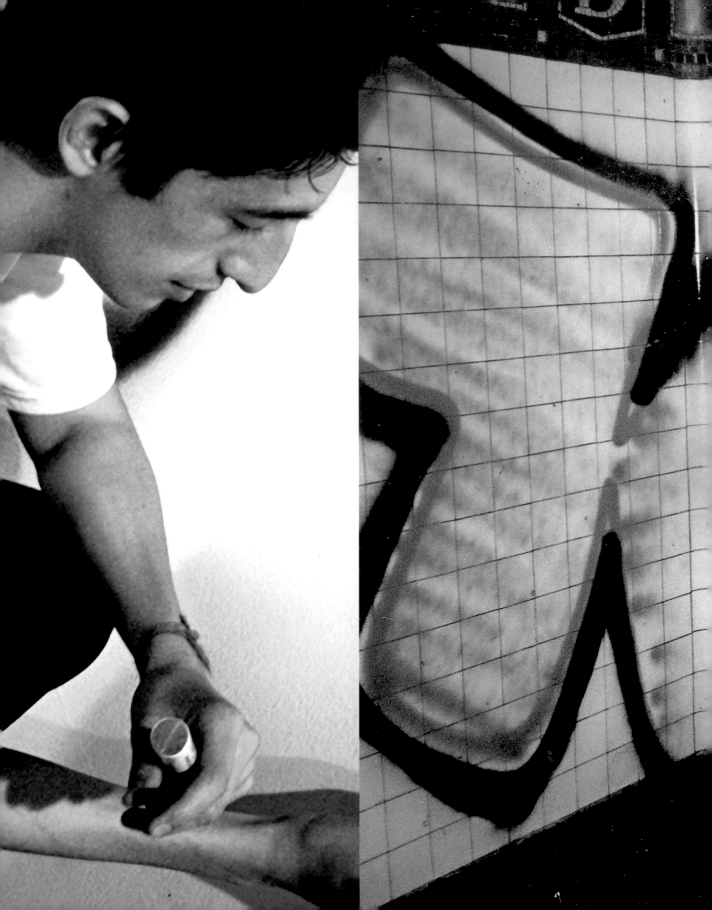

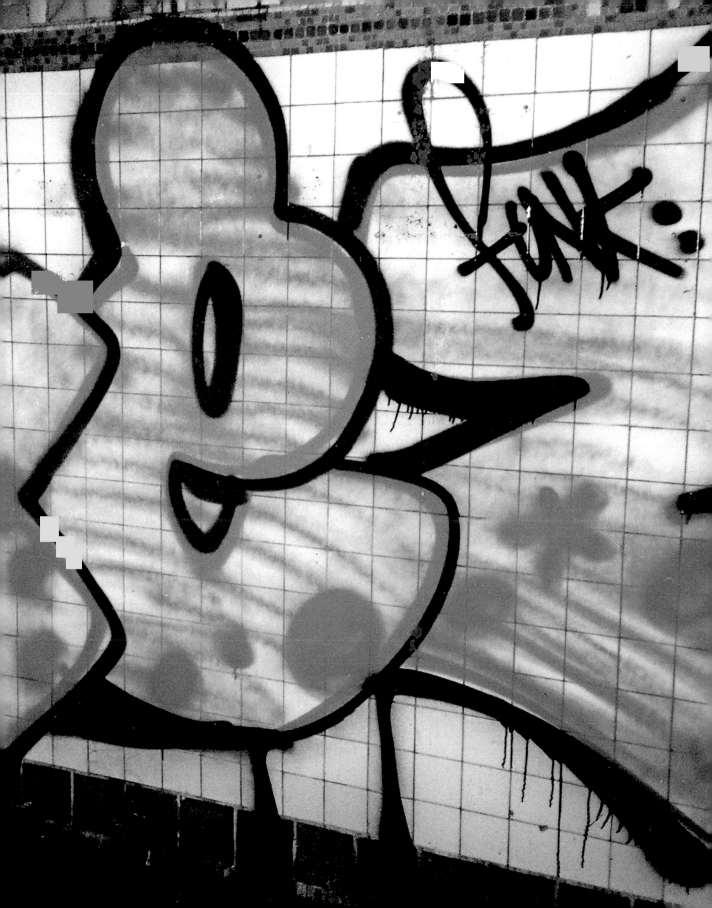

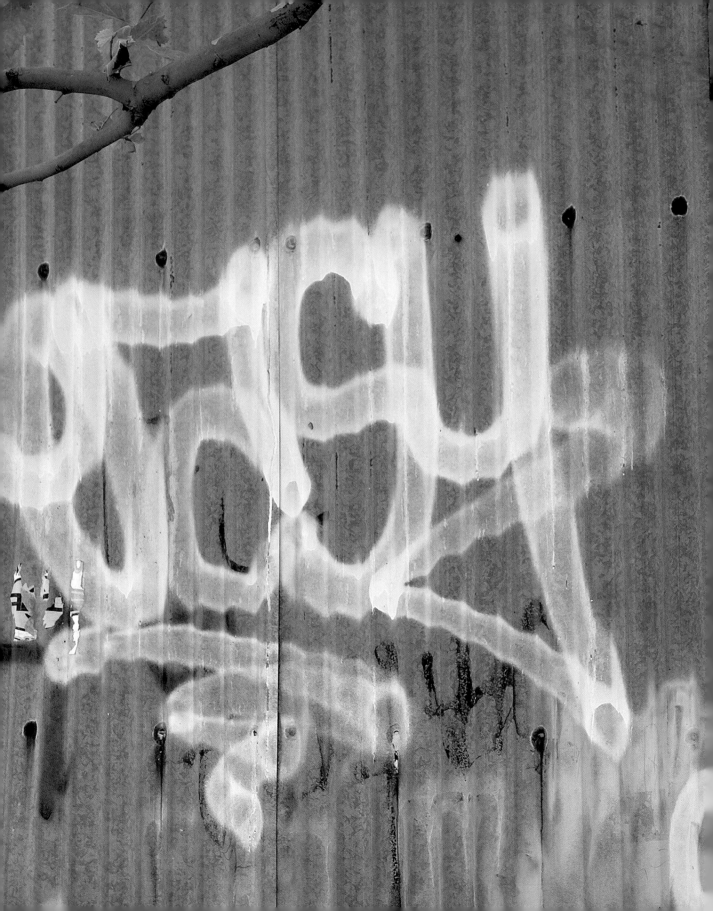

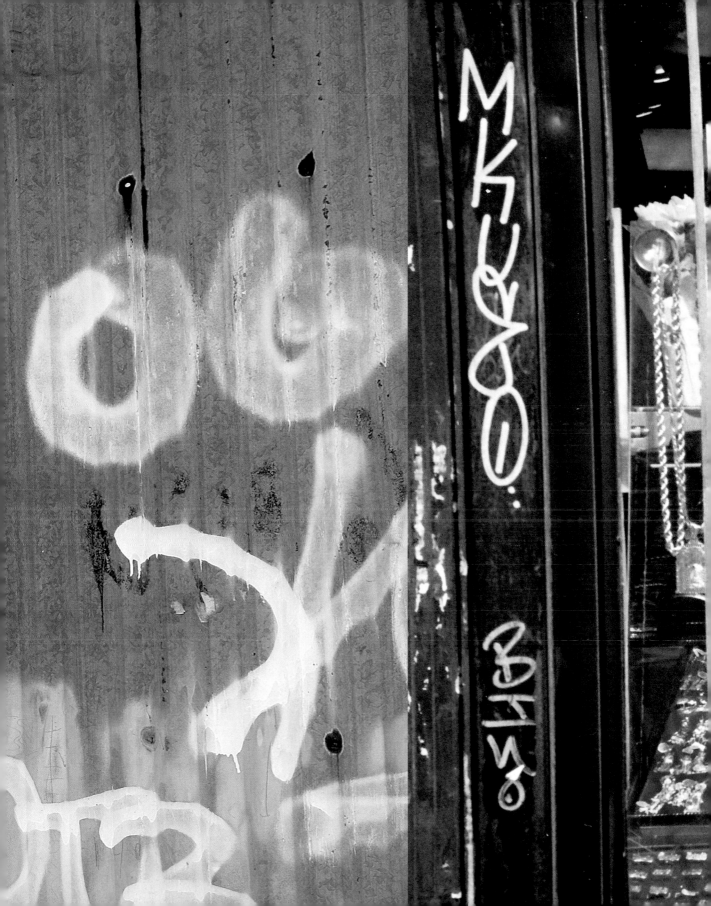

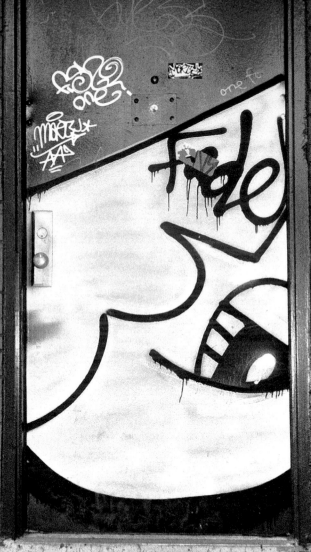

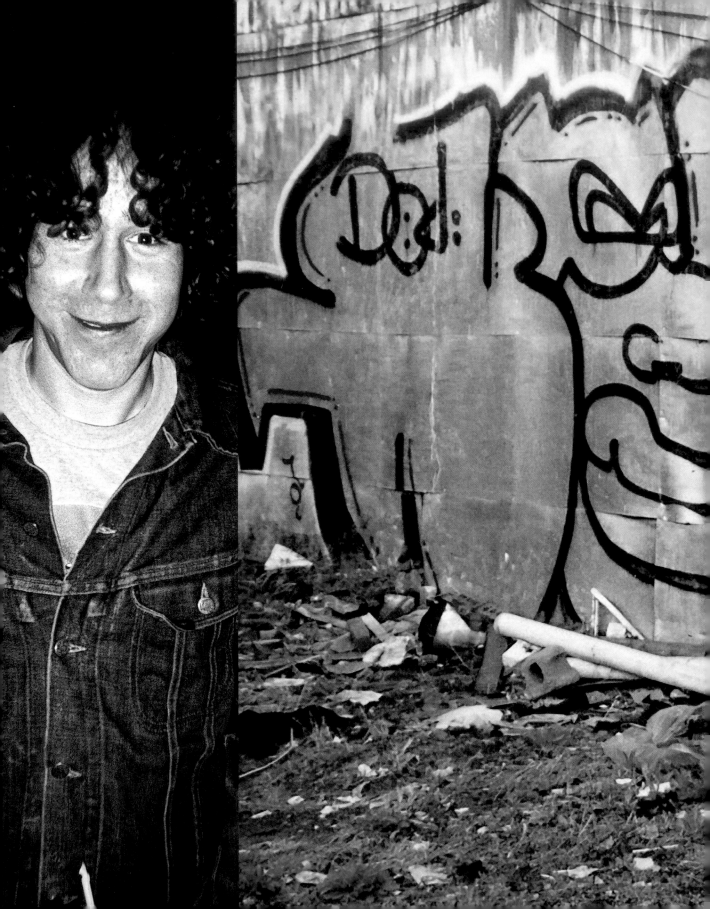

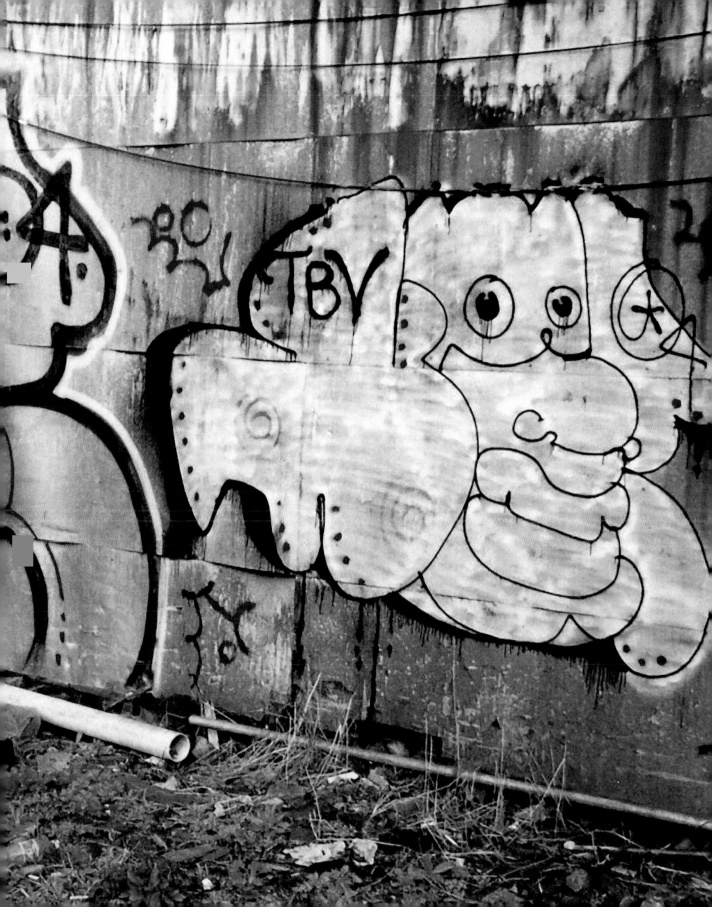

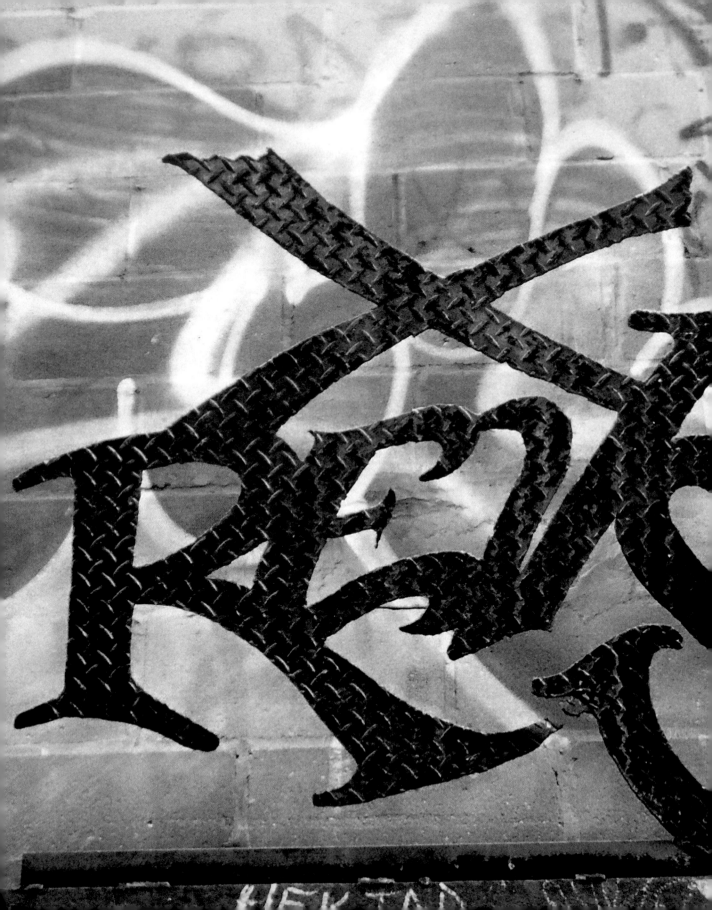

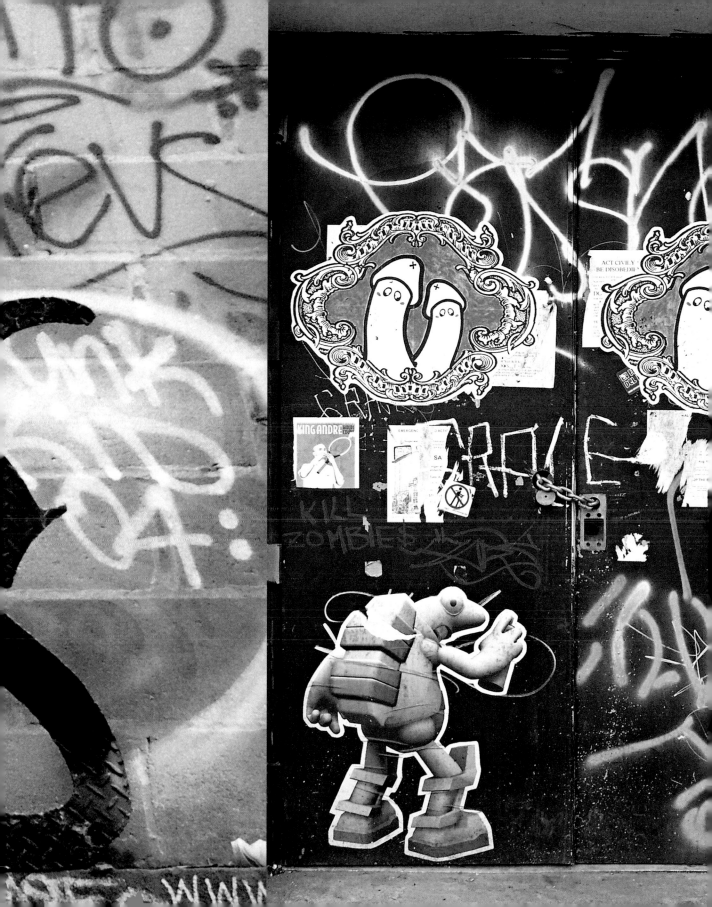

...props

It is absolutely essential that every writer understand the basic principles of graffiti, the most important being the golden rule. The golden rule states that writers are primarily meant to constantly recreate and constantly reinvent and make shit better. SETUP

What I say is this: If ain't no one lookin', write on it. LES

You have to get up everywhere. If you don't get up everywhere, you're not All City and then, if you're not All City, what's the point? Why are you taking the risks if you're not going to become a King? If you're not going to become the person that you used to look up to when you first started? GIZ

Prominence NEEDS to be the first hurdle in a picture's inclusion or not. That's what graffiti is based on. Getting up, going all-city, bombing, killing shit, KING. That's what graffiti IS. Graffiti is all about getting your fuckin' name up as much as possible. If it's anything else you need to start including pieces real quick. NATO

Anytime you go All City—that's the same as getting a platinum record. I got multiple platinum on that tip. VFR

Being All City, fighting with people, not wanting to be friends with graffiti writers, only wanting to be with them on a bombing level... that whole world doesn't exist anymore. Now you can do graffiti on the Internet, do it in your backyard, take a couple pictures of it, make a website, put some stickers up downtown and be the man. EARSNOT

It's like, Each One, Teach One, you know what I'm sayin'? NOXER

There's one thing about Bombing. To get fame and to be really respected, you can't buy it, you can't steal it, you can't cheat it. You have to just earn it. Even if someone doesn't like you, they can't take that away from you. GIZ

Is it important for me to see people go All City? Of course. I just like to see that shit. But at the same time, my life has evolved and I don't really want to be at a point where I'm running all around the city trying to write graffiti, cause for me it's done out of desperation, and out of a kind of low point where I don't care what happens, which is kind of raw and people love it for that reason. But it's a bad place to be, it's not coming from a positive thing. EARSNOT

Wait till you see what I'm gonna paint now. BLADE ONE

I've got a repertoire of styles, simple and complex. I'm more into that aspect of taking it to the all-out other levels. Extrater restrialcelestialesotericaltongue -twisticalmysticalvisuallinguistic al–type stuff; the complex mega structurally norm- wrecking against-the-grain stuff. PHASE 2

I see every one of my fill-ins, I see every one of my tags, and if you diss them, you know what? I want $5,000 dollars for each one. TECK

When it comes to graffiti I'm just doin' it so that God can get the glory, so that Jesus can be praised. JESUS SAVES

Listen, I'm a legend, right? I'm a pioneer from the Old School, from b-boying, to dj'ing and mc'ing as well as graffiti and being in all cities worldwide... Anybody who disrespects Old Skool is disrespecting me personally. And I'm not the one that go for it. Straight up! I'll be like a fly on shit when I come to get you. You know what I'm saying? You hear me? CASE 2

Graffiti made me feel important. I became somebody. I was admired, respected and feared because of that mysterious air that accompanied the early writers. I was able to focus on one goal. Before that I had no goal in life. Lived every day as it came. I learned how to set goals. Like hitting all 100 buses in a depot in one night, or hitting every Number 1 train station from South Ferry to 14th Street in a couple of hours. By focusing I was able to set higher goals like starting to read one book, passing my GED, then on to college and medical school. It made me feel important in front of the people that meant something to me. It showed me how to set goals for myself, especially short-term goals, and gave me a feeling of accomplishment. C.A.T.–87 [Juan Tapia, M.D.]

I've made them all... not what they are, but gave them inspiration to become who they are, from doing graffiti. CASE 2

I don't claim that I invented the throw-up. ... When I did my first throw-up I didn't really think I was doing the first throw-up... If you want to call me the inventor of the throw- up, be my guest. I don't like to say I invented this or that, you know, it can sound a little arrogant. MICO

Don't think you're the shit because your name's on the wall. Big fuckin' deal. Find out the cure for cancer. I fuckin' done, in my opinion, more graffiti than anybody, and so what? Big fuckin' deal! That and 50 cents will get you a cup of fuckin' coffee. JA

I'm so big you know, Kez is so big and Kez is so famous, that, you know, people just hate him. And that's what I like. When somebody's jealous of someone else, it's like that person admires them. KEZ 5

...art/world

How do we deal with the art world? How does the art world deal me? VFR

[The art world's response to graffiti has been] disgraceful—absolutely disgraceful. Class bound, terrified, superficial, and condescending. To have initially hit upon this stuff as something sensational, and then to have backed away abruptly because the establishment didn't like it and these art world types really weren't willing to break with their customers, who were part of the establishment... Richard Goldstein, author

The art world is going to keep you out of it; they're gonna keep you away from the cookie jar. Now what? Create your own cookie jar, yo. You don't have to like me, but you've got to respect my work. VFR

The approach as a graffiti writer to the art industry... How do we do this, how do we do this? I don't know. I think they got the whole thing rigged; the way they got it all set up, you know? Like accepting certain art forms and rejecting others, in reference to graffiti being the 'others'; but a blank-like canvas is totally acceptable and I don't get it. VFR

Technically, by its own definition, the word art defines practically everything in the universe and couldn't possibly exclude, if anything, our contri-bution to the world at large. PHASE 2

This isn't art. It's a cancer that spreads. Officer Eddie Segui, NYPD Graffiti Habitual Offender Suppression Team (GHOST)

Art is not simply about aesthetics and pleasure, it provides us with imagination and context and raises questions. It sharpens us, makes us both vulnerable and fierce. Art is tension without bloodshed, and it alone can turn sorrow into meaning, and sharpen the moral imagination. Toni Morrison, keynote address, Aspen Ideas Festival, The Aspen Institute, Aspen, Colorado, July 8, 2005

I remember, winning an art contest and shit, it wasn't good, I didn't get the same stimulation as from doing something that was real, maldad [mischievous]. I was always being programmed to do bad shit. I was a bad kid, bro. On the block I was known as being a bad kid. KEZ 5

When someone is given such obvious talent, it makes sense to promote that person, to promote him in what he loves, but I have to add that graffiti is scary—to me. RATE'S mom

Many people are of the opinion that established institutions such as the art world and media are some of the biggest culprits in the practice of racism in modern society today. MICO

I like tagging. The art aspect of it isn't why I do it. It's for graffiti writers. I want to see a good outline, I want to see a good fill-in. So when I write graffiti, I write big tags, big marker outlines. That's what I want to see, so that's what I do. EARSNOT

Graffiti art, whatever, is all derived out of tags. Tags were what there was and then tags were the fuckin' outline. JA

The people who started it were artists, and artists have more in mind than proving their machismo. The masculinity game is there, and is an important part of what motivates the work, but it's not the whole story. It also has to do with the self as a creative, assertive force. That idea of making your mark on the world has enormous appeal across all kinds of class divides, and I think that's why graffiti broke out of the upwardly mobile working class where it began and became an instrument that has mass appeal for young people. Richard Goldstein, author

Art, I like. But this is not art—this is vandalism. Peter F. Vallone, Jr., NYC Council Member

Not to say that magazines and the Internet and art shows and books and corporate branding with graffiti are all bad. I'm not saying it's ruining anything. If anything, it's helping to keep it alive, but at the same time it's killing it. But is it killing it more or is it helping to keep it alive? I think it's killing it more. RATE

To denounce tagging, which is where graffiti came from and grew from and eclipsed anyone's wildest imaginations and fuckin' progressed from, that's like saying 'the sperm is insignificant, and the egg is insignificant, and fuck that, we don't need that anymore.' It's losing the basic elements of where it came from and what it's about. JA

There's nothing artistic about a tag. A tag is just expressing anger or whatever. You can tag blindfolded on the phone. Pieces are considered art. NIC 1

When all else fails, what do they turn to time and time again to add that cool factor and street cred? Graffiti. Graffiti is something which by definition cannot be commodified because it is illegal, and this is exactly what is so appealing to consumers. RATE

There's a disturbing trend, and it's nationwide, where these major corporations are trying to gain some kind of street credibility by promoting criminal activity like graffiti. Peter F. Vallone, Jr., NYC Council Member

The mainstream graffiti thing on websites and in magazines—most of the people you see on those shows, they don't even get up. Other people see that and think that's the shit, and it's not at all. Street graff is the shit. NAISHA

One of the things I love about graffiti is that it's unmarketable. Because, even though it's hard on people who would like to make a living from their art, it can remain relatively free and fluid and authentic, compared to other movements which are co-opted at an ever-increasing pace. I think that's why graffiti has maintained its integrity for the last 30 years or so—it's not corrupted by the marketplace. The very thing that marks it as a renegade form, also keeps it pure. Richard Goldstein, author

Aerosol culture is a multi-headed entity existing within a circle, which consists of many components. I'm a writer who writes, and I represent writing. I don't consider myself an artist nor do I see a point in debating whether or not what I/ we do is art. PHASE 2

The first thing I ever was was a graffiti writer. BREWS

Mom, how do they get on the roofs and do that? is what I asked, looking out the 7 train's window. Don't look at that, it's bad... Secretly I was in love. I never belonged. Now... they don't belong. I would be loved. I could be an outcast and still be loved... loved, loved! NATO

Simultaneous to this internal turmoil in my family and in the community a cosmetic art boomed. This art was Hip Hop and graffiti. These arts flourished side by side in every oppressed community in New York City. At the time it was an eyesore to mainstream America, but at the same time it was an escape for the children of these areas. SKUF

...and then my mom started seeing me write Darks and she was like, 'Why don't you write Light or Love?' or some corny shit. DARKS

I was an outcast. Nobody wanted me. There, I said it. I just had to let you know. In retrospect, my identity crisis guided me into my graff career. NATO

To most people it's just a throw-up, but to me it's a self-portrait, a reflection of how I feel and how I look without flesh as an incarnated entity. SABE

Do it because you really want to do it, not for some kind of so-called fame. But if it's in you, it's in you, and it's a nasty bug and it's in people. It happens, it's a fact. JA

I'm an enigma. I'm 2,000 people. JA

I get excited when I see his work on the street. When I first saw the rat symbol, I was kind of repulsed by it; but, I guess that's exactly what the idea is —it's repulsive… and the conditions we live in are repulsive. That's the message I receive. RATE'S mom

I've painted passionately, aggressively, and destructively for the past seven years. It is my way of releasing stress, an outcry for attention, and when that wasn't enough I would resort to self-mutilation: carving up my chest, arms, and forehead or taking hallucinogenic drugs to fill up the vacancy from within. SABE

My works reflect my experiences in life—who I am, and where I was raised. When I was a kid, I questioned a lot of things as I sat in front of my building. COCO

Graffiti was something to me when I started learning the differences of what people have for style. And that's why I became who I am with my own style. I didn't ask for it to come like that, but it just happened. CASE 2

We had no idea whatsoever that this culture of writing your name on walls and trains and buses and whatever would go global, like it is today. We had no idea; we just wanted to be famous ourselves. MICO

It is all about having an identity and simply being recognized and acknowledged, which we all need. If people cannot get that kind of validation through socially acceptable means, they will find other ways to fulfill their needs. Dr. Patricia Hill

The rat is a symbol for city life, I guess; it became my throw-up. It's like my savior and the bane of my existence simultaneously… both city life and the rat. It's a two-sided coin, you know? RATE

What's inside the person is what comes out on the wall. EARSNOT

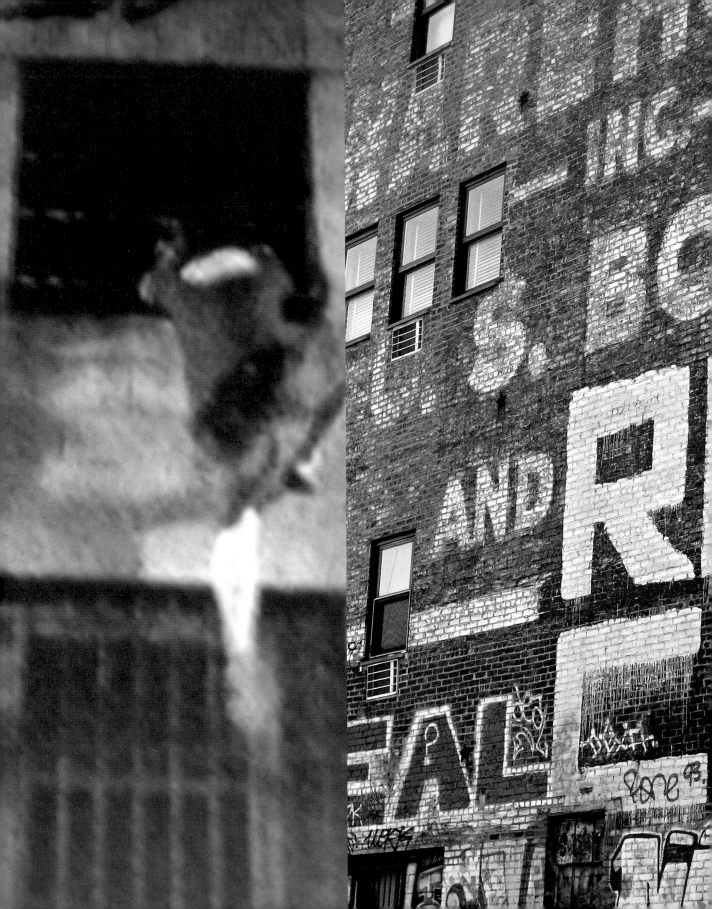

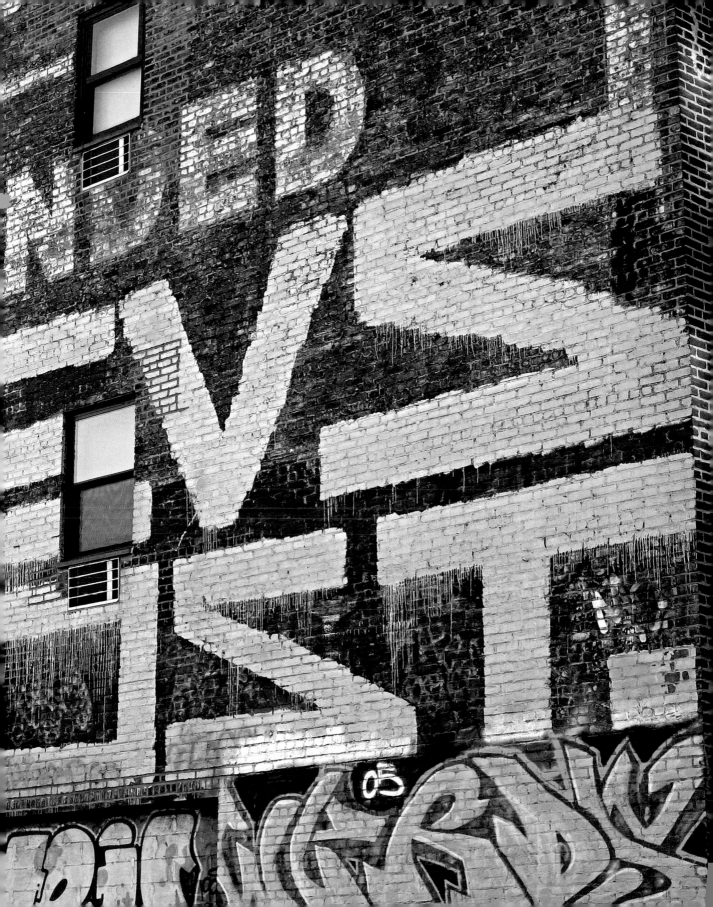

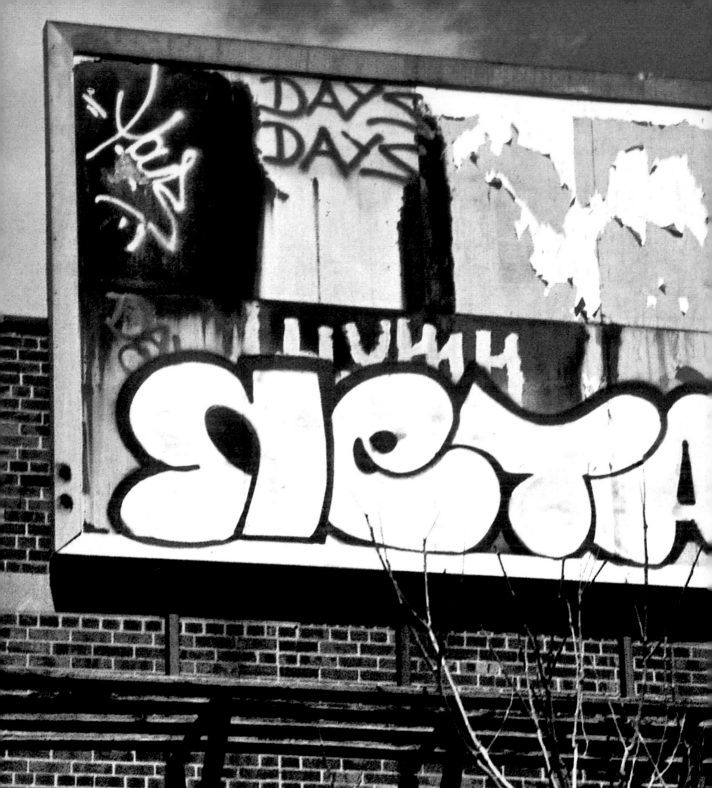

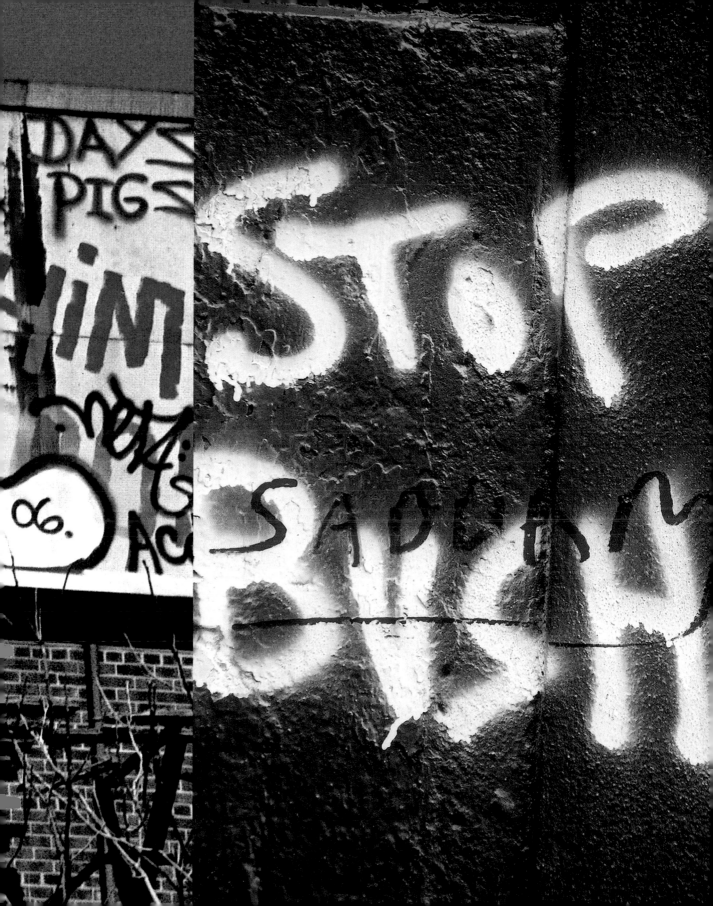

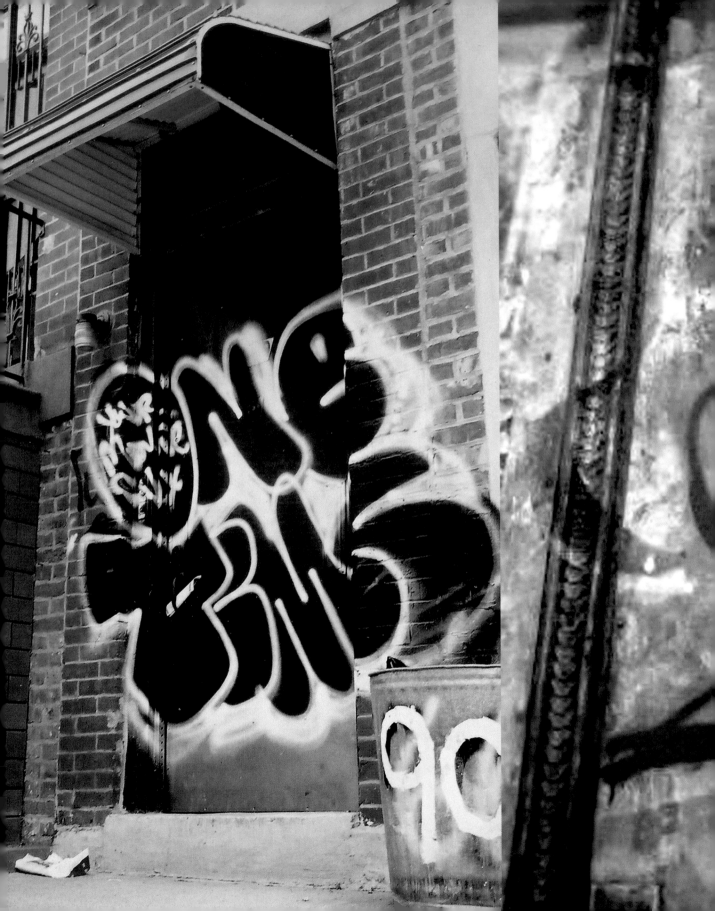

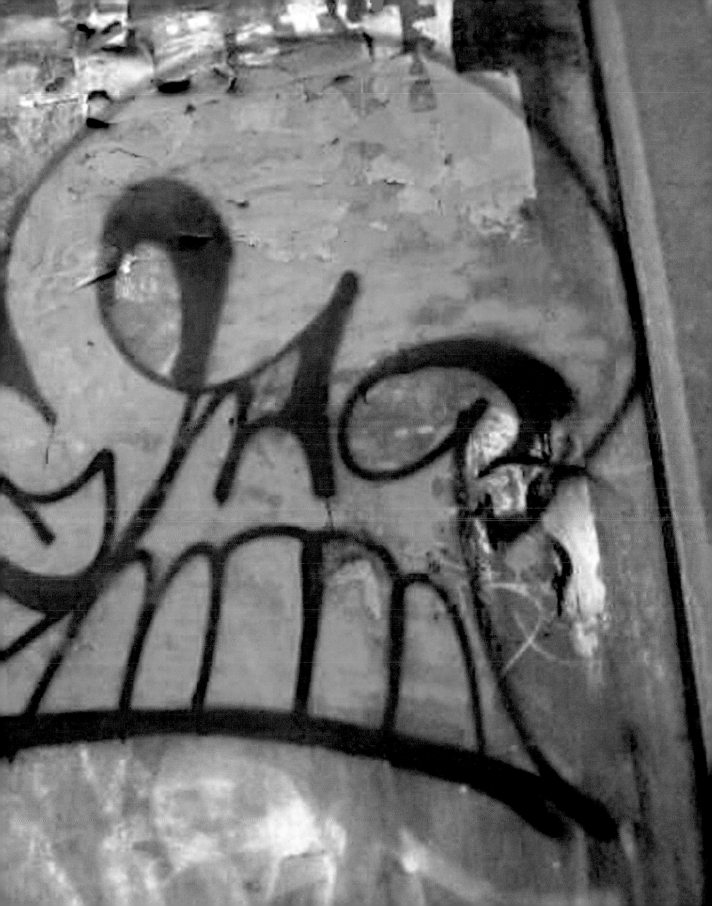

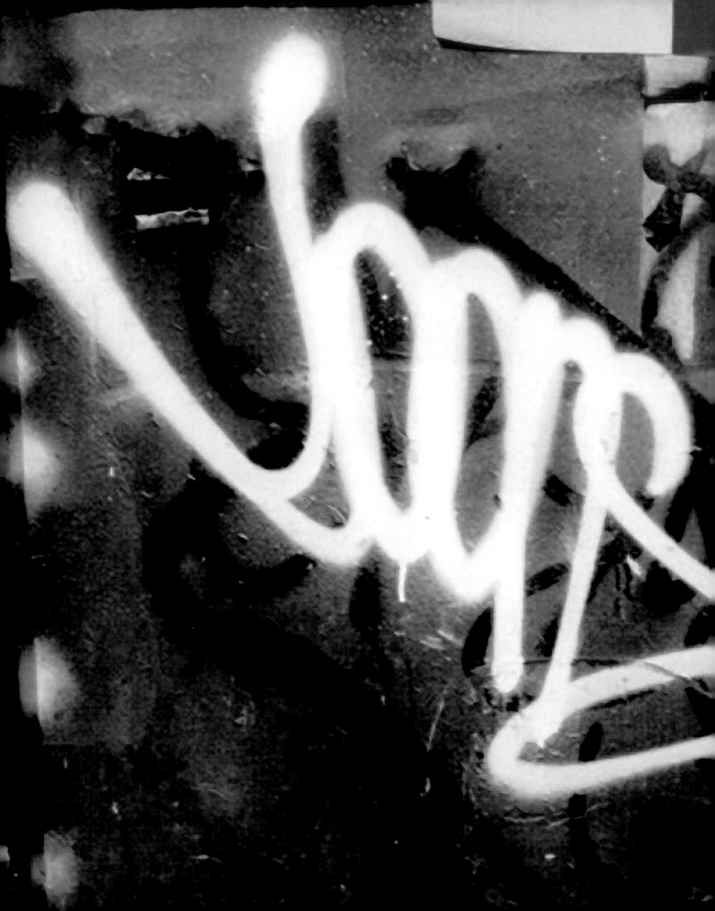

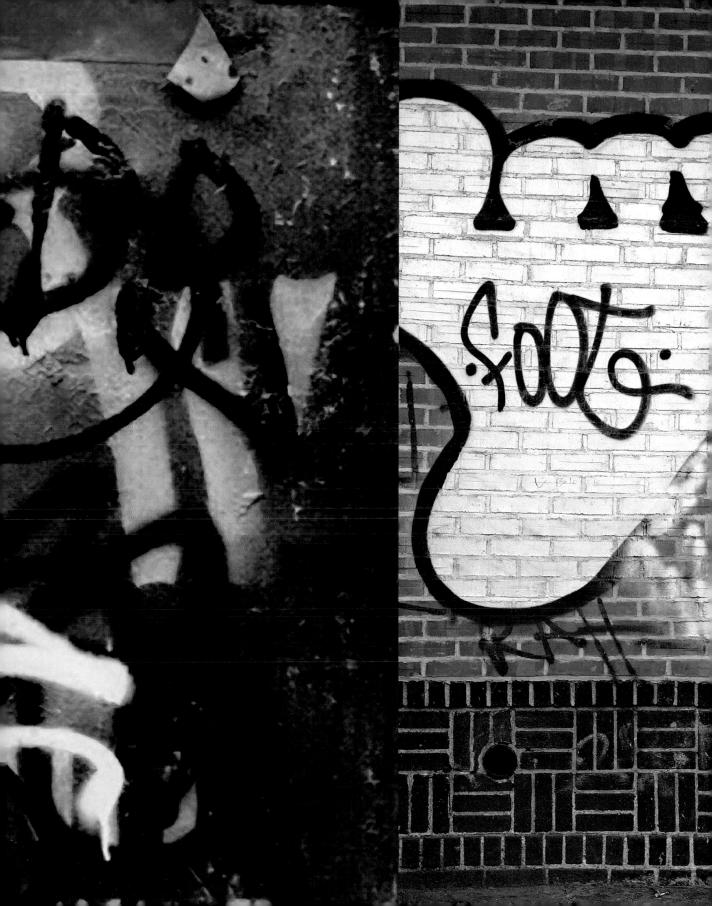

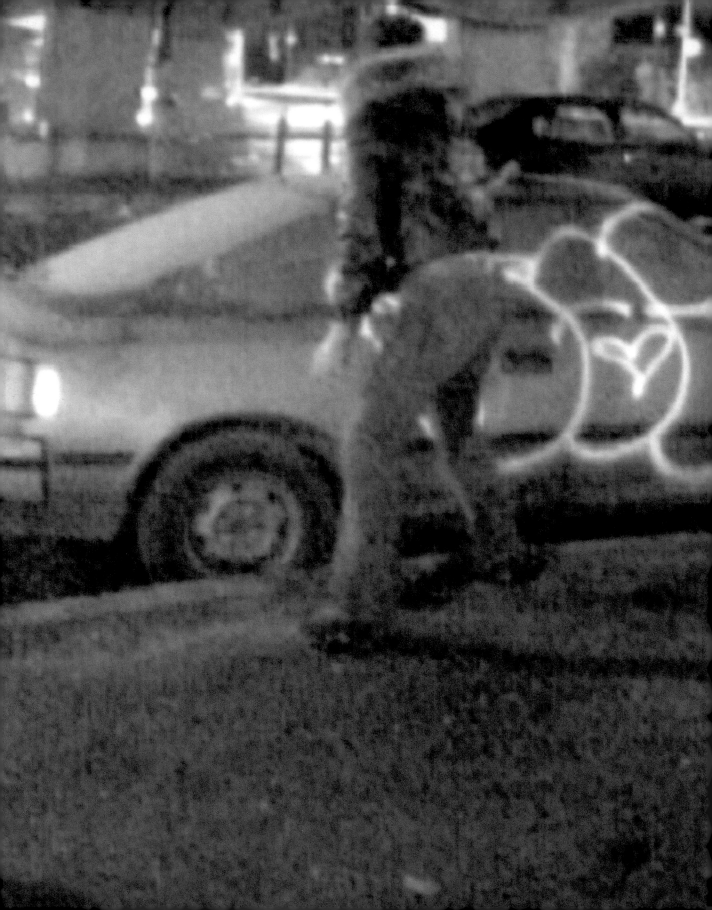

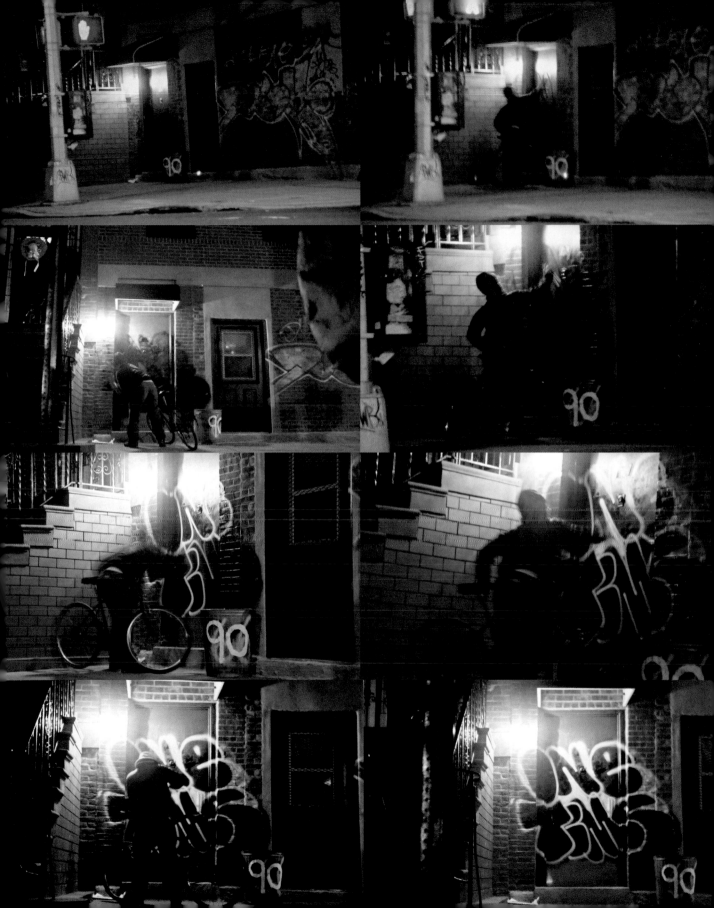

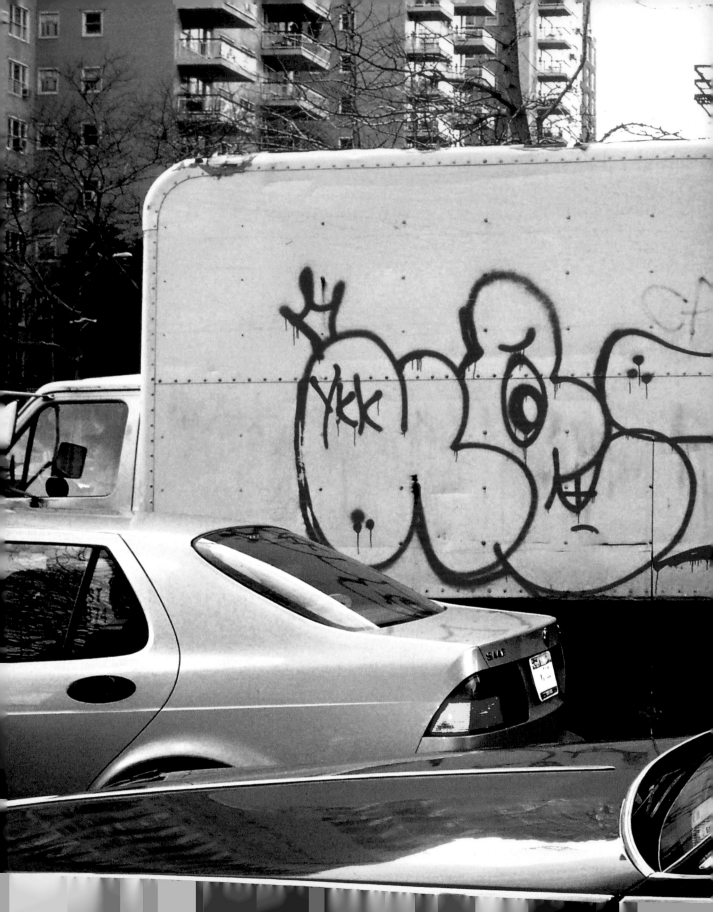

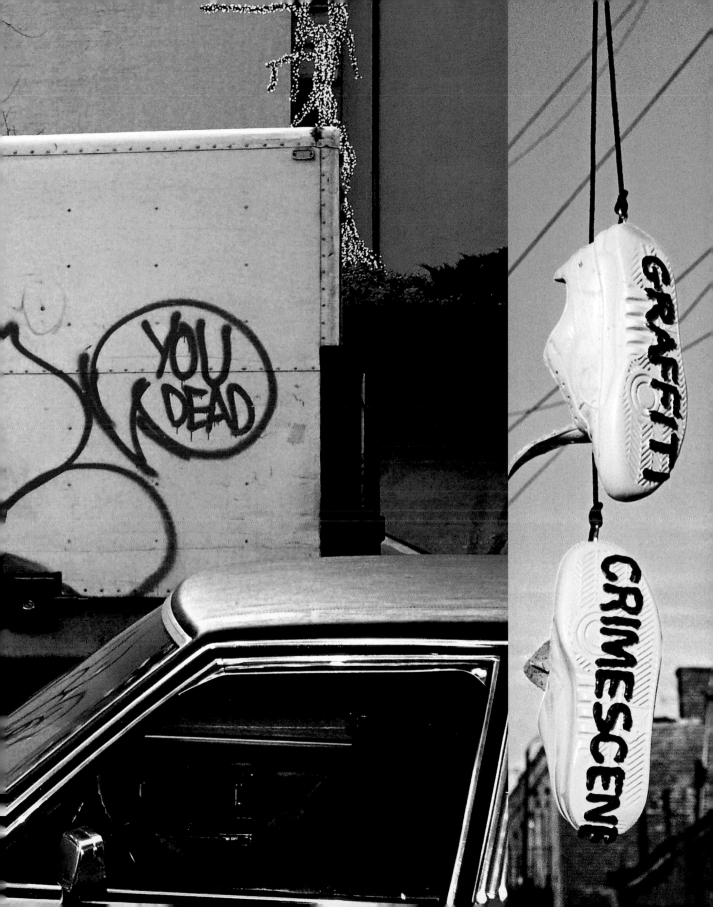

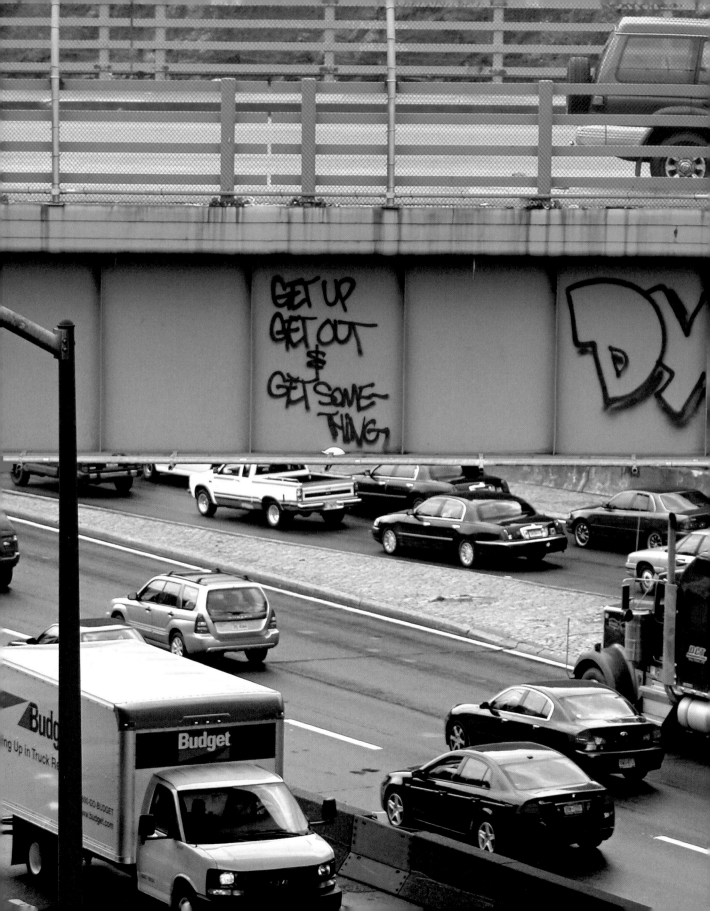

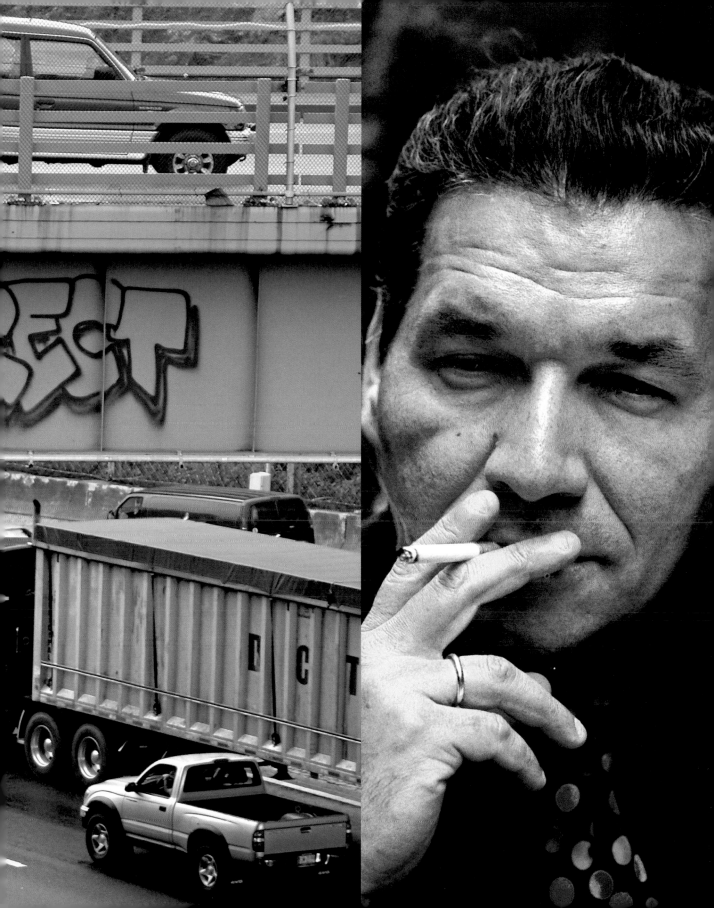

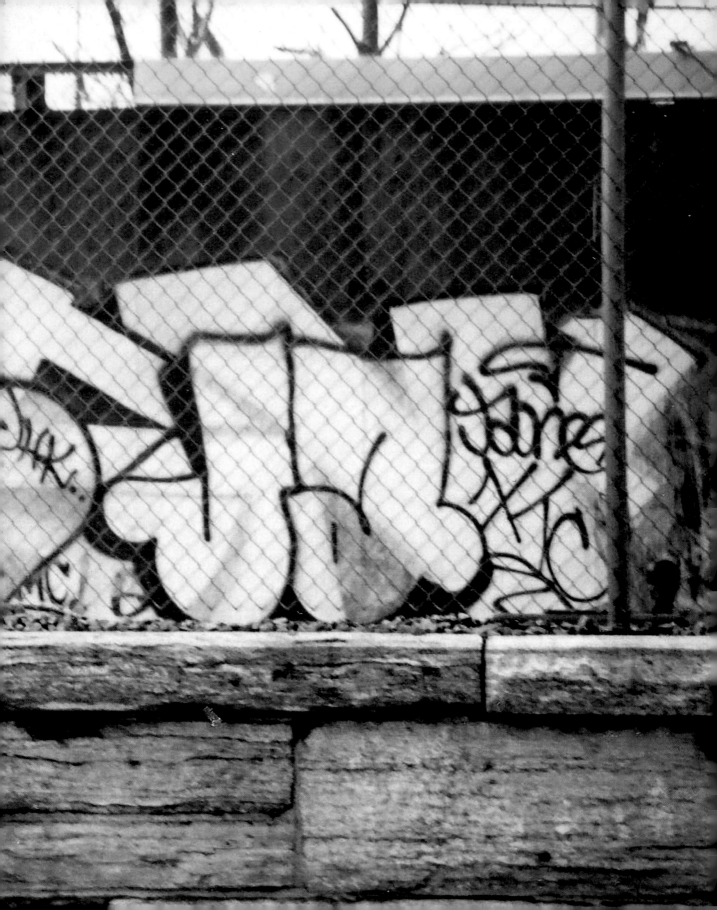

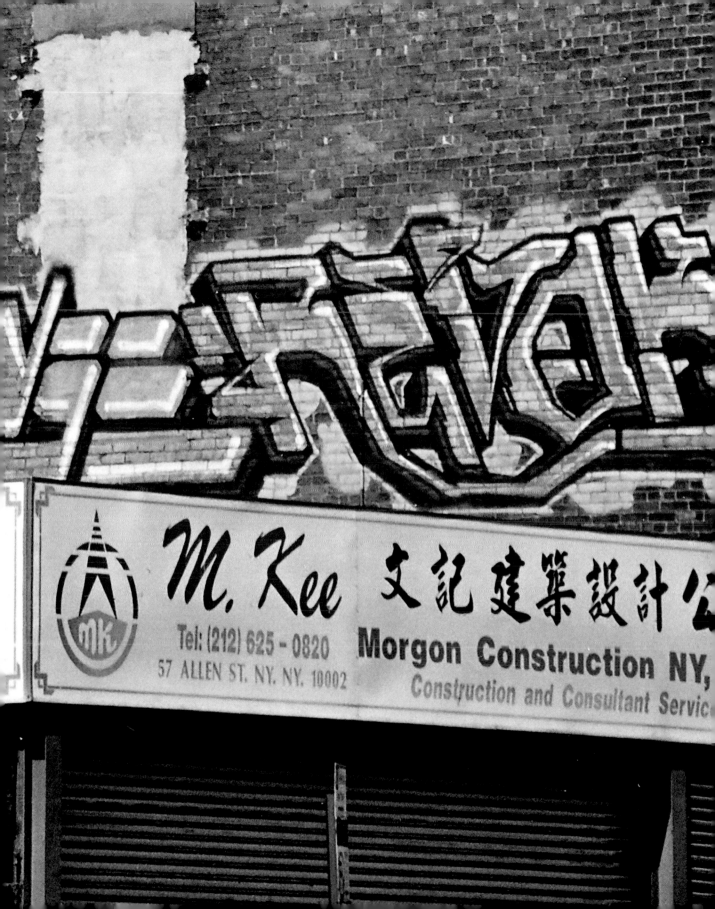

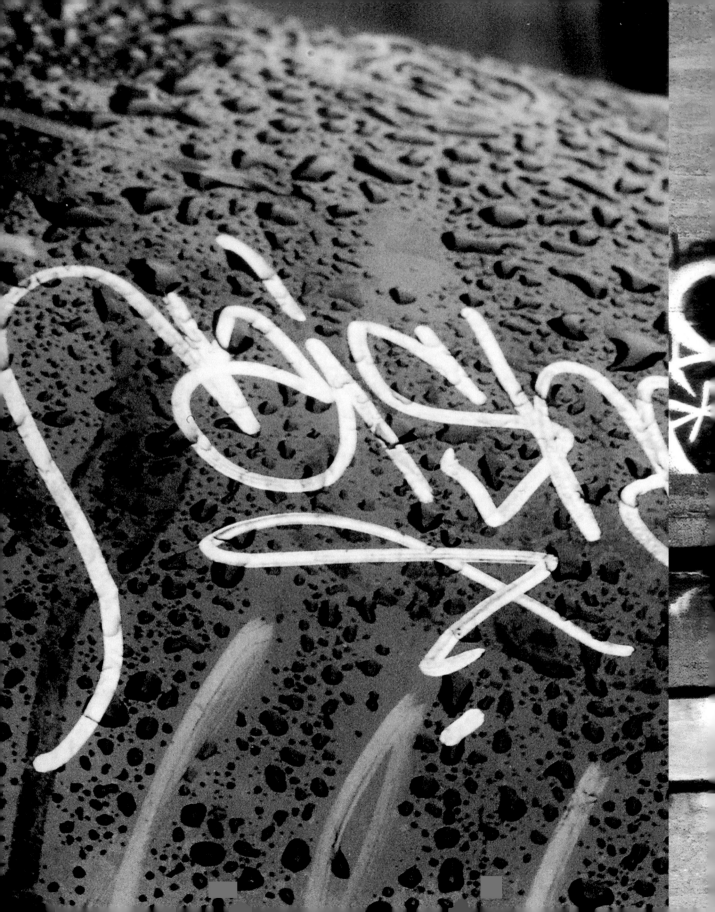

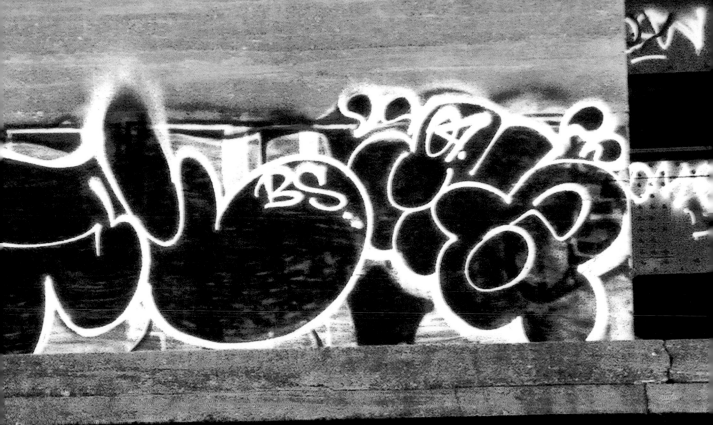

USA

Good
Buff?

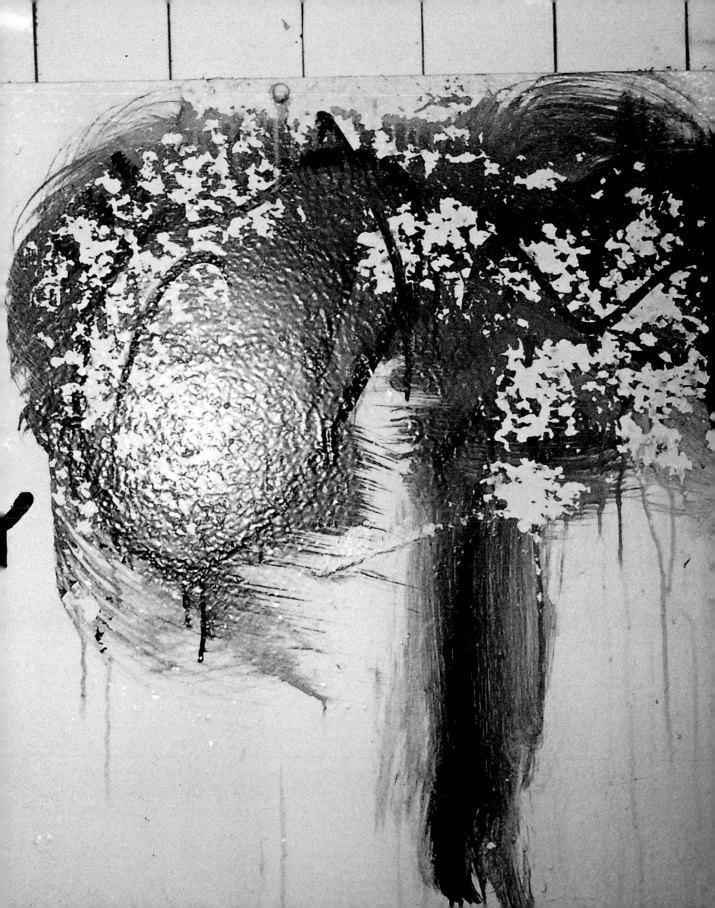

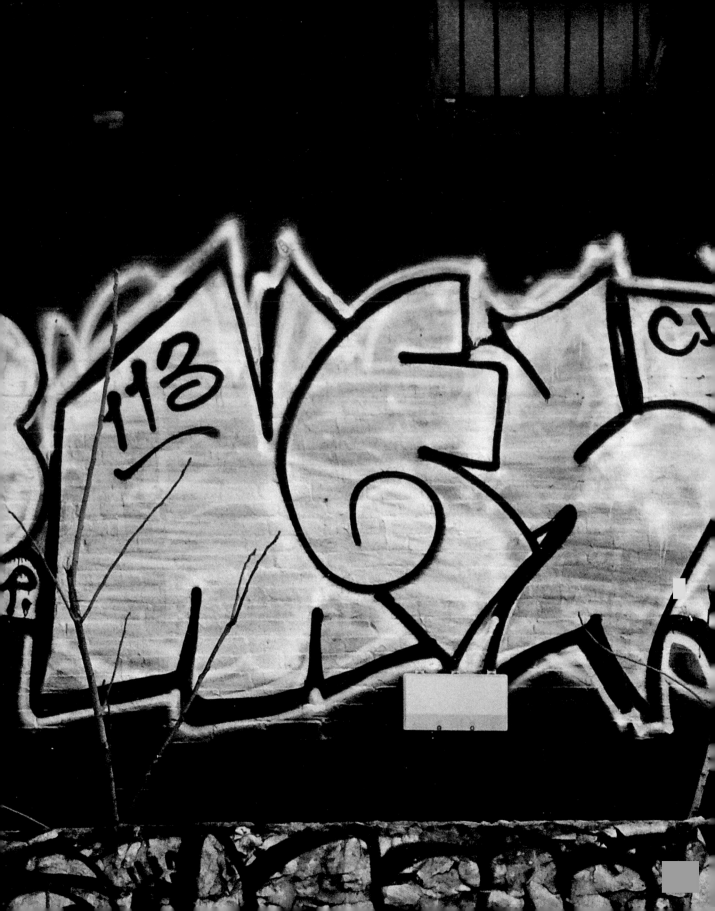

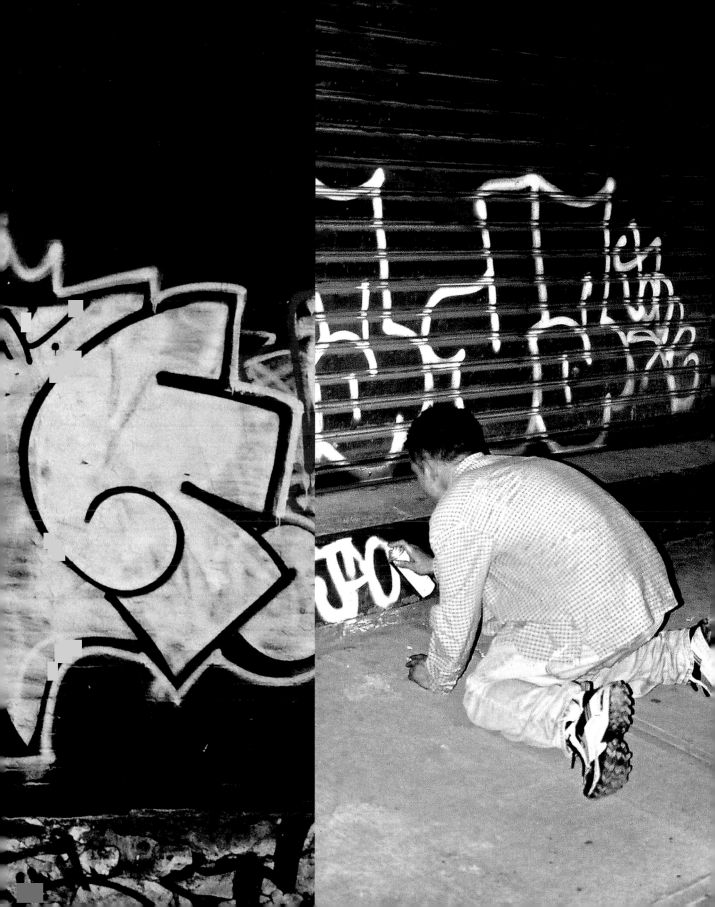

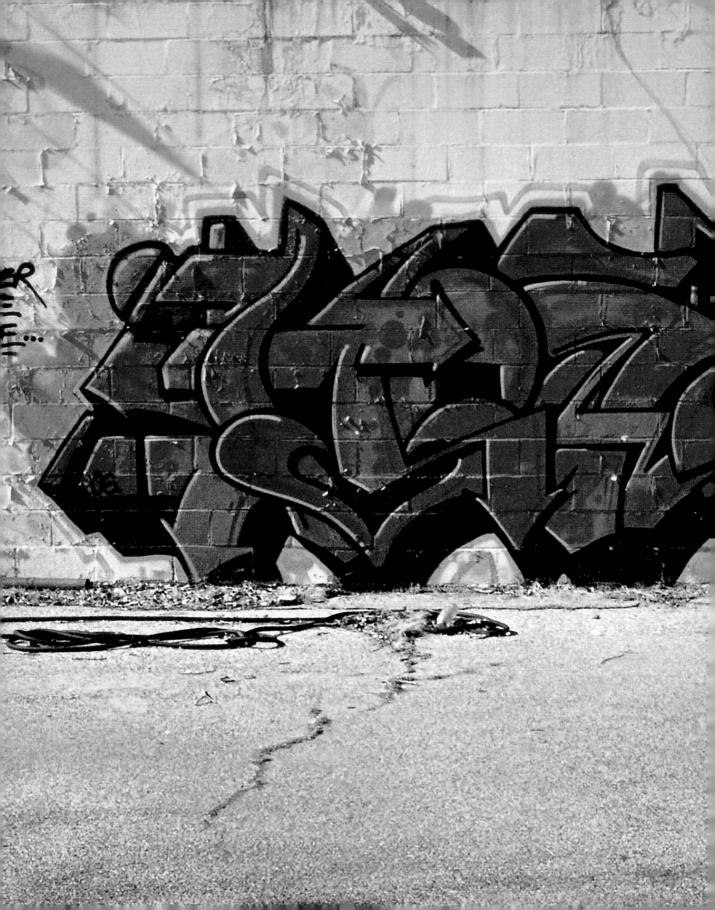

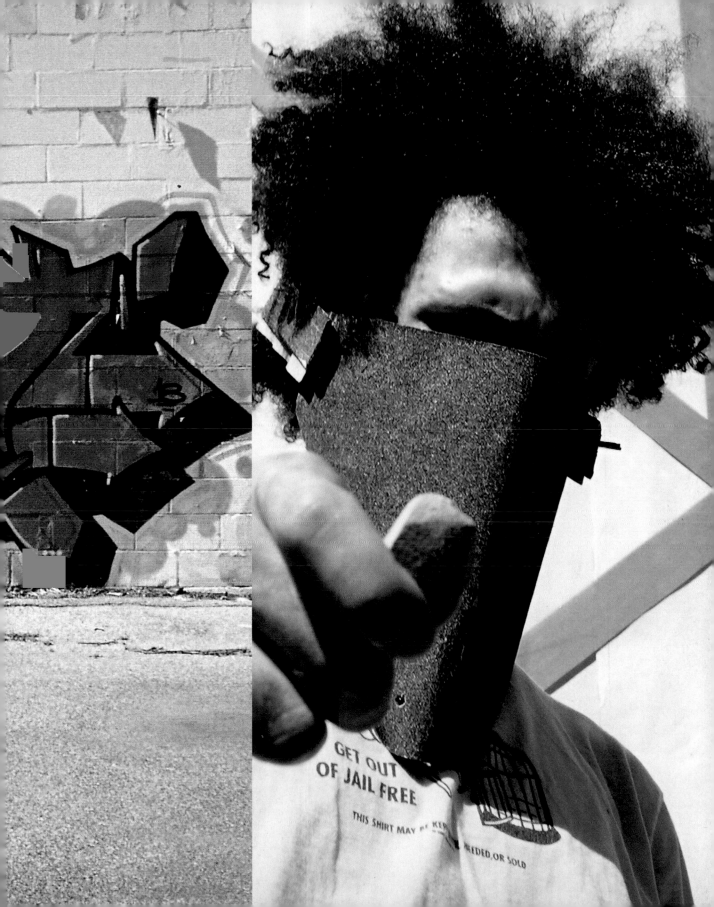

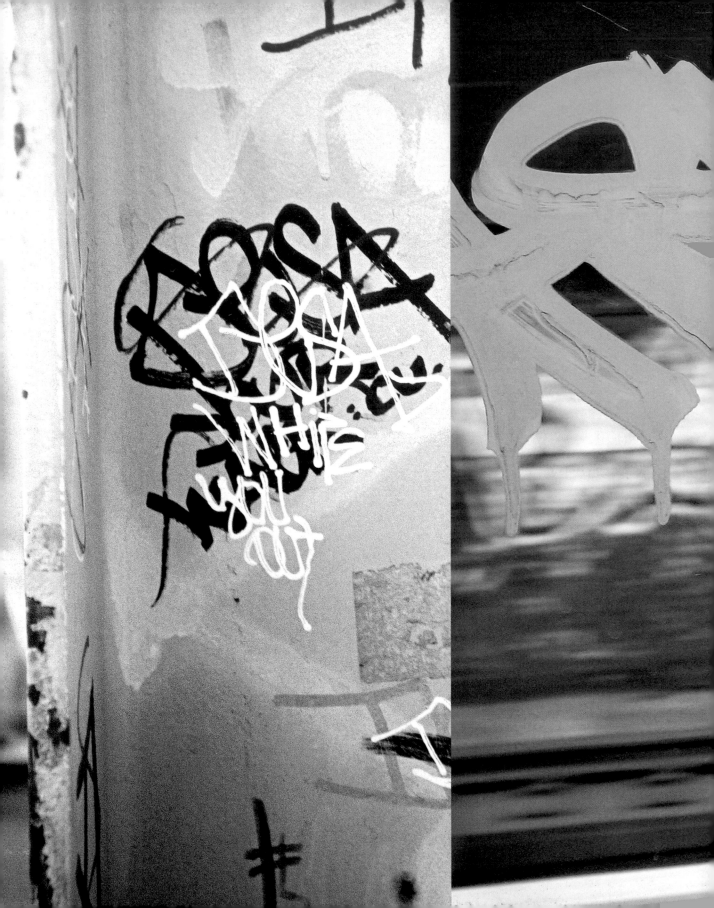

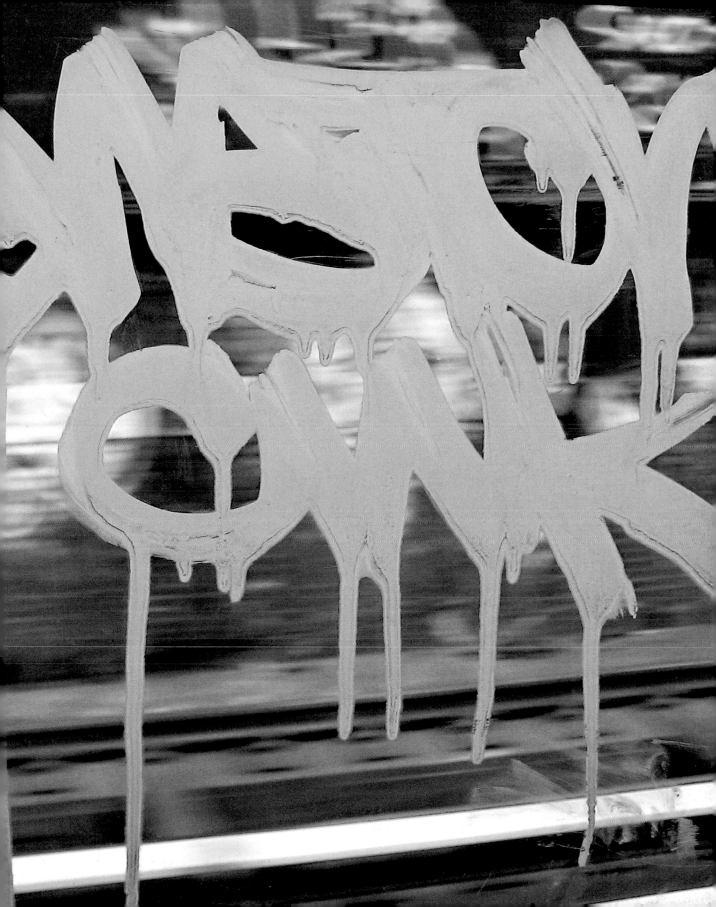

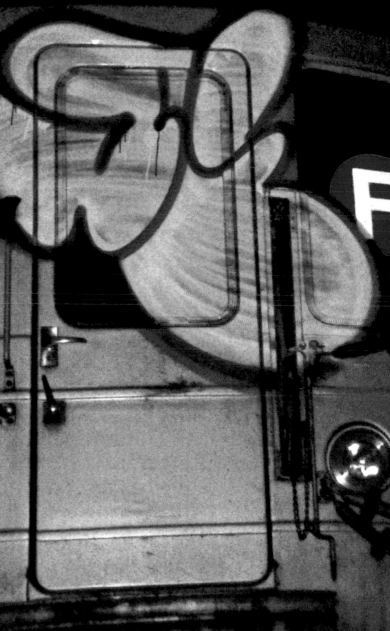

Original Prescription Strength

Non-Drowsy

Claritin®

24 hour
Allergy

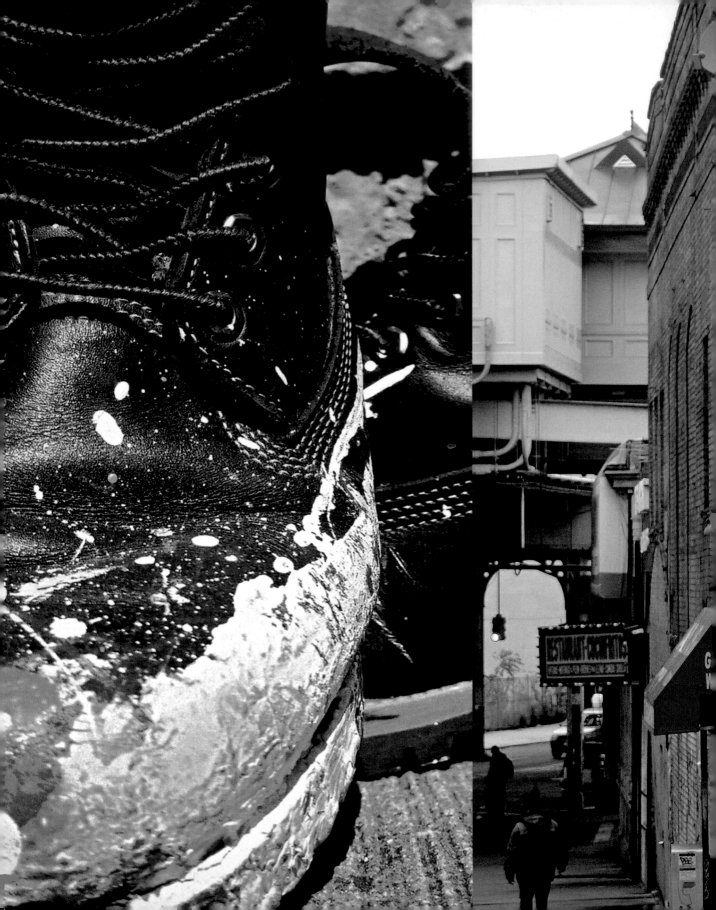

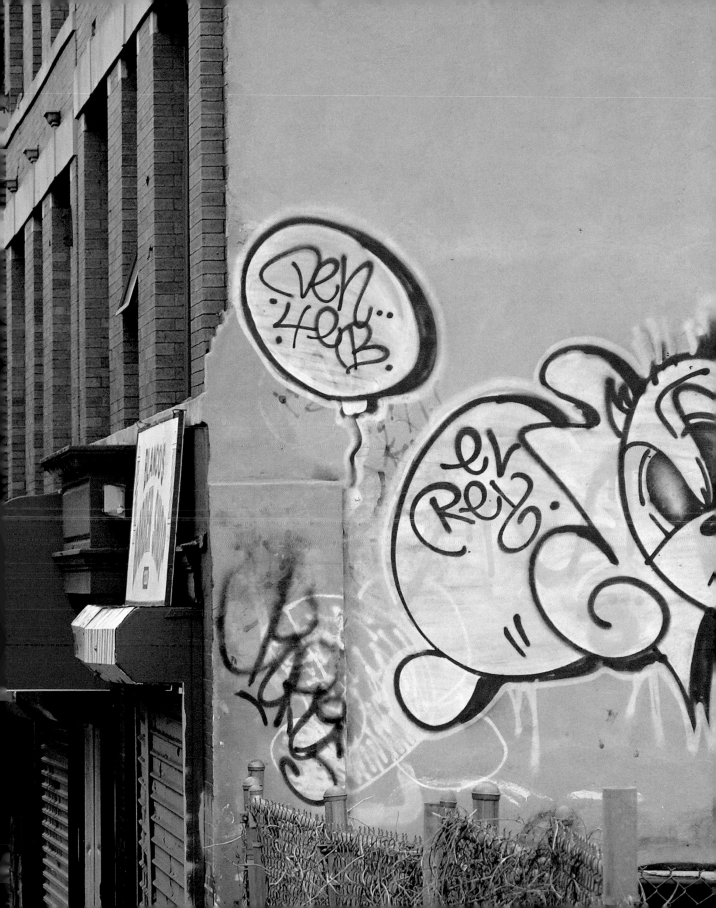

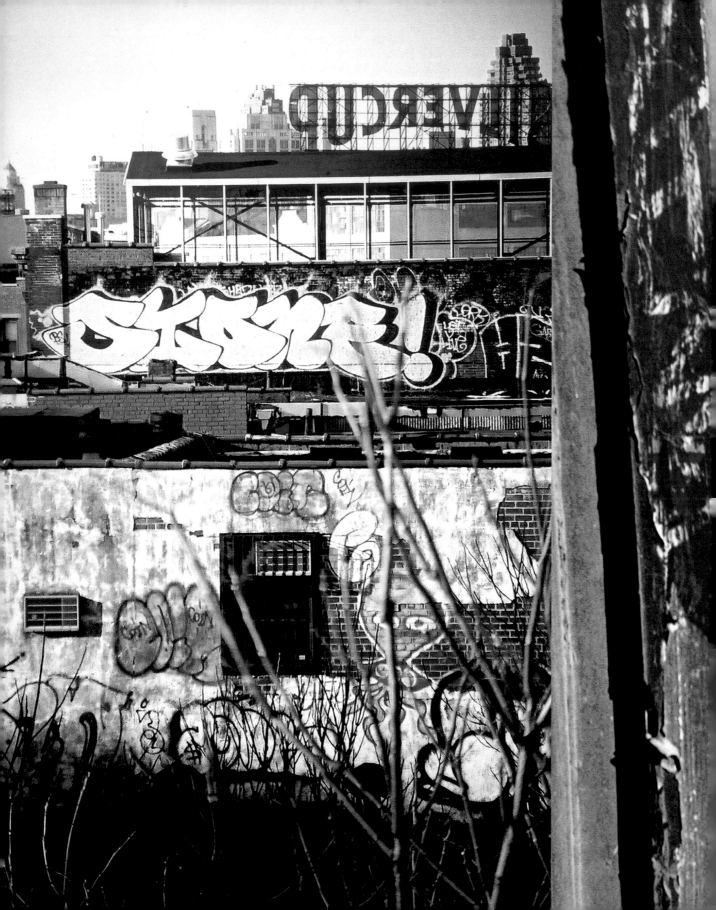

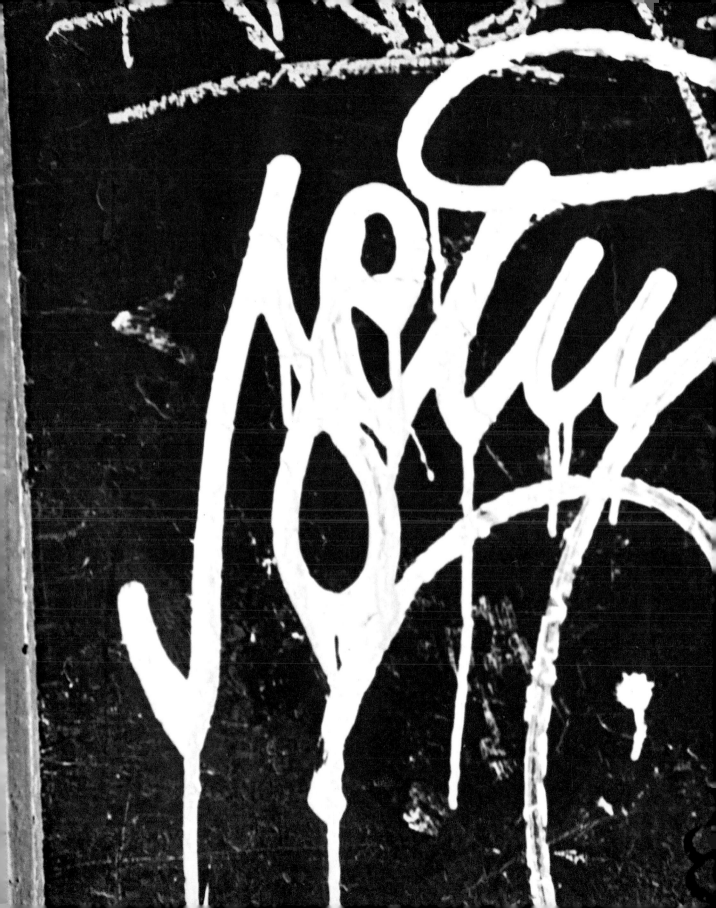

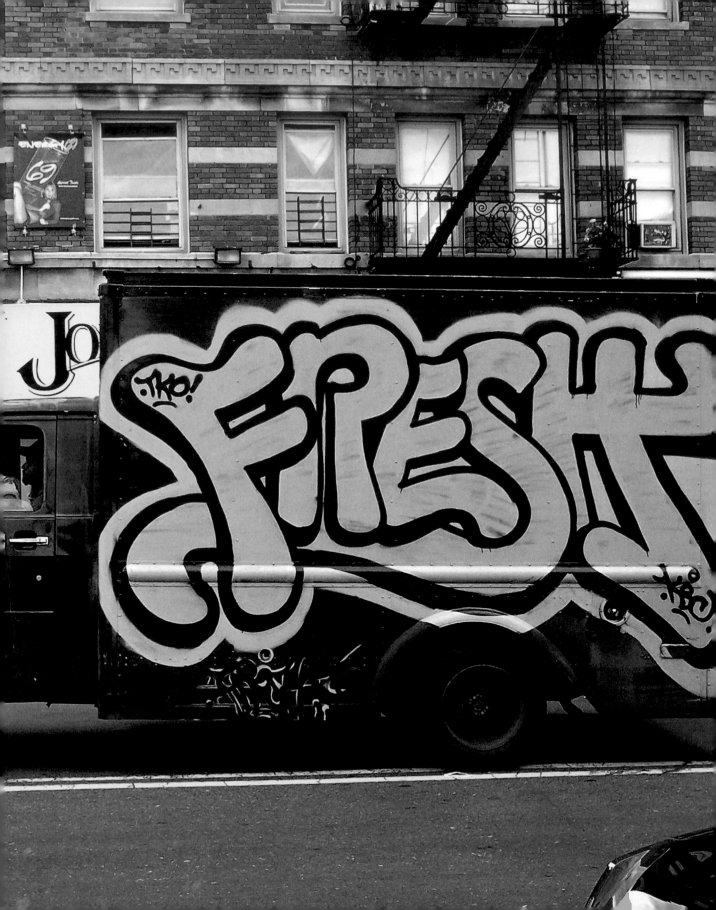

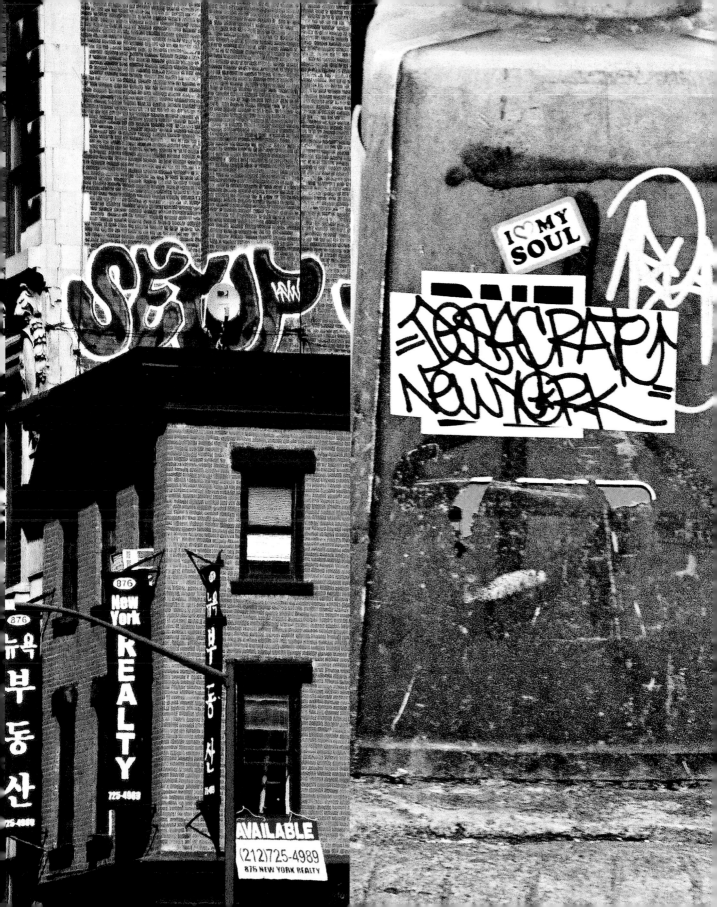

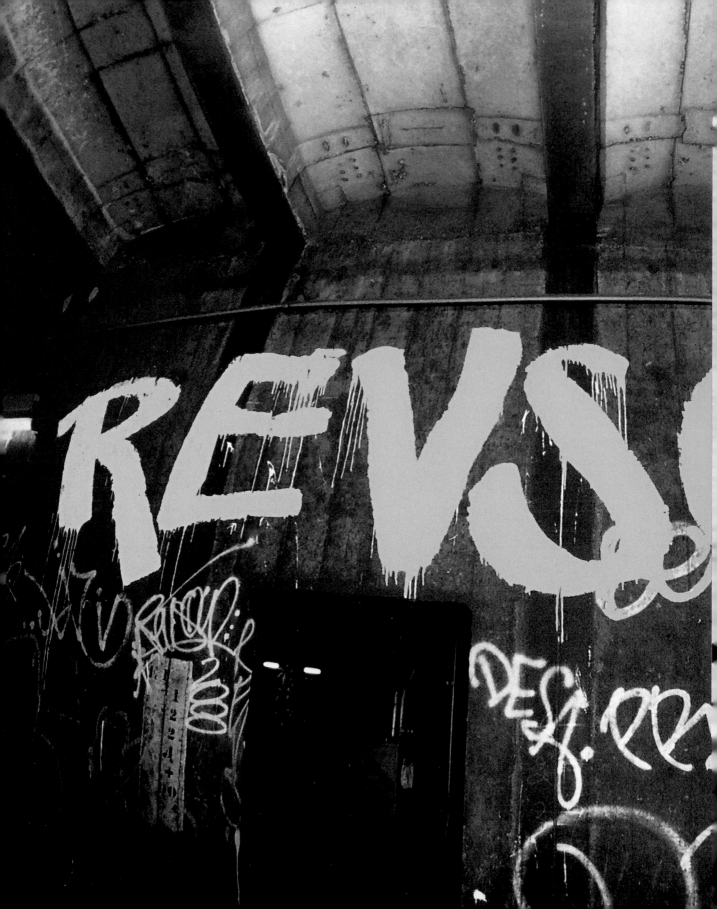

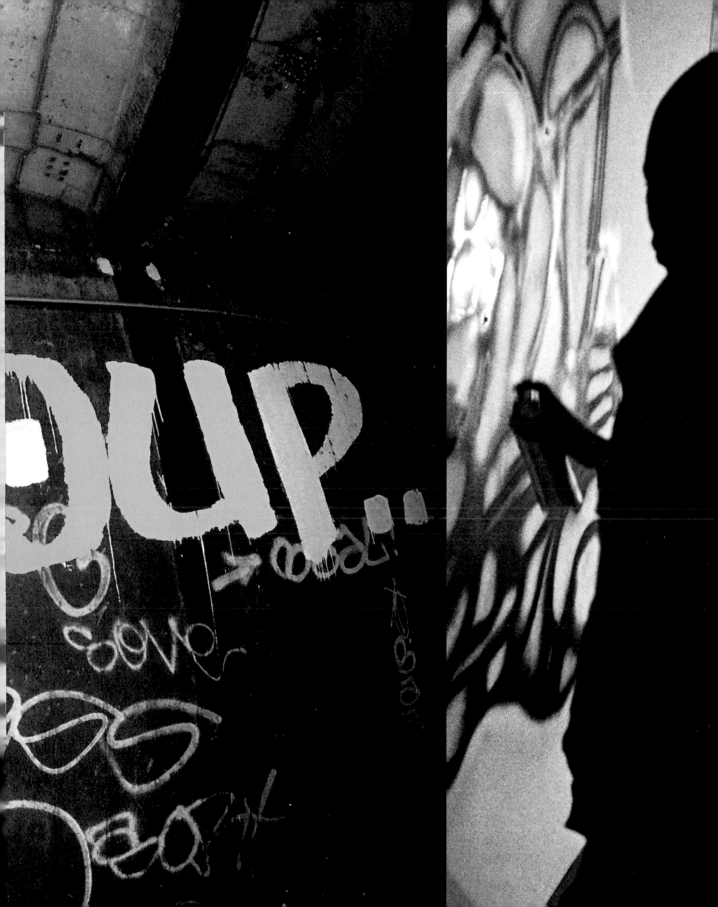

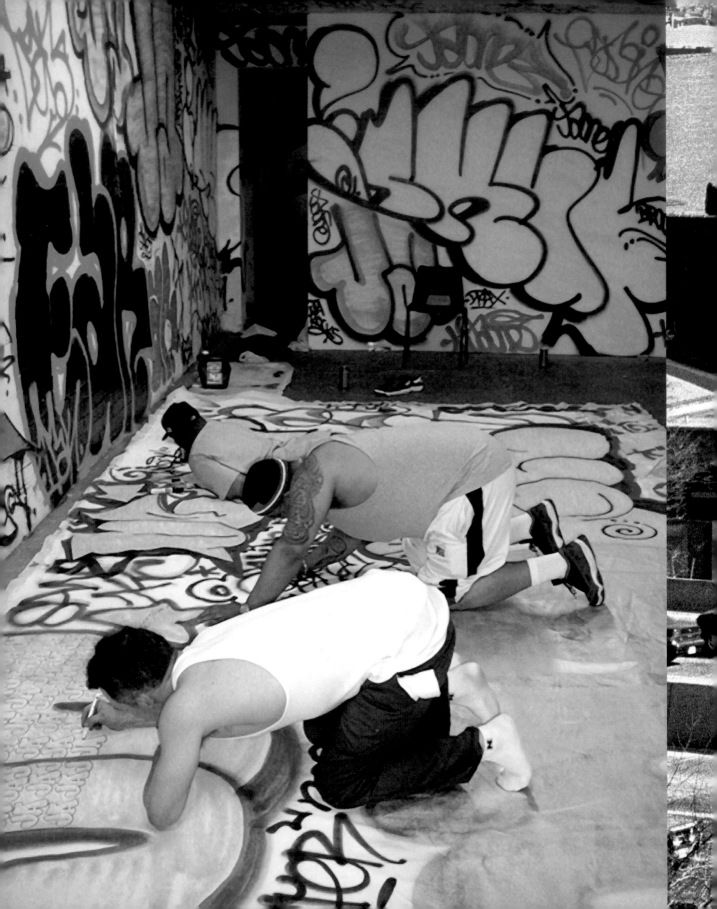

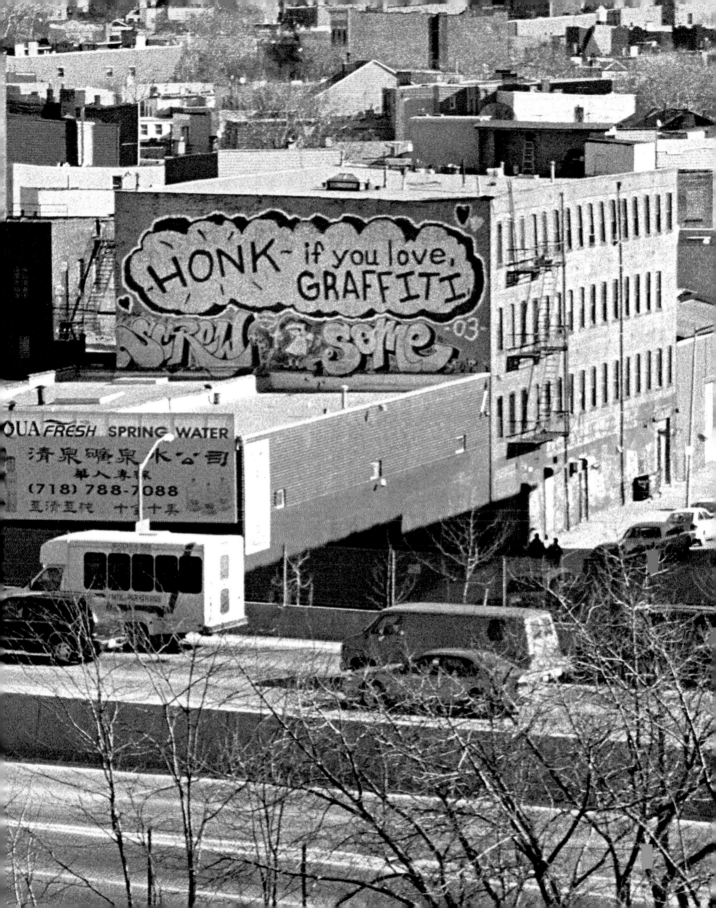

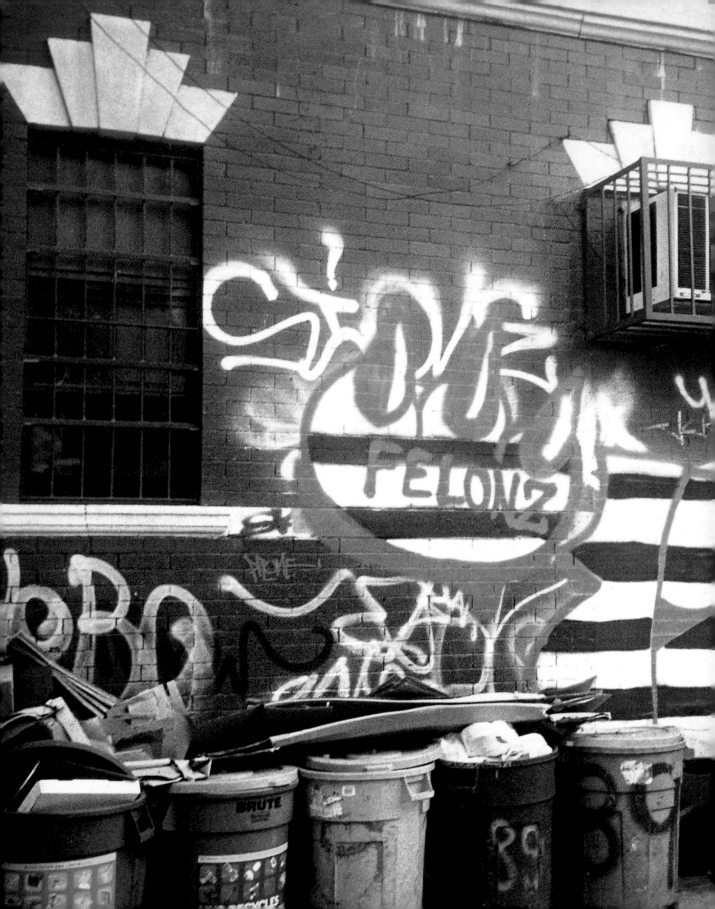

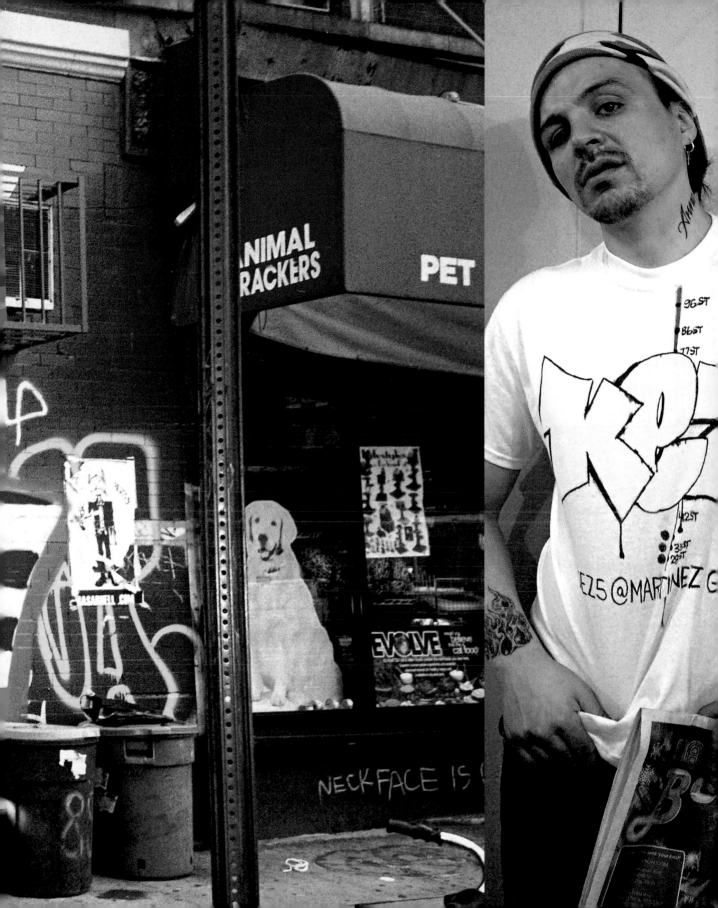

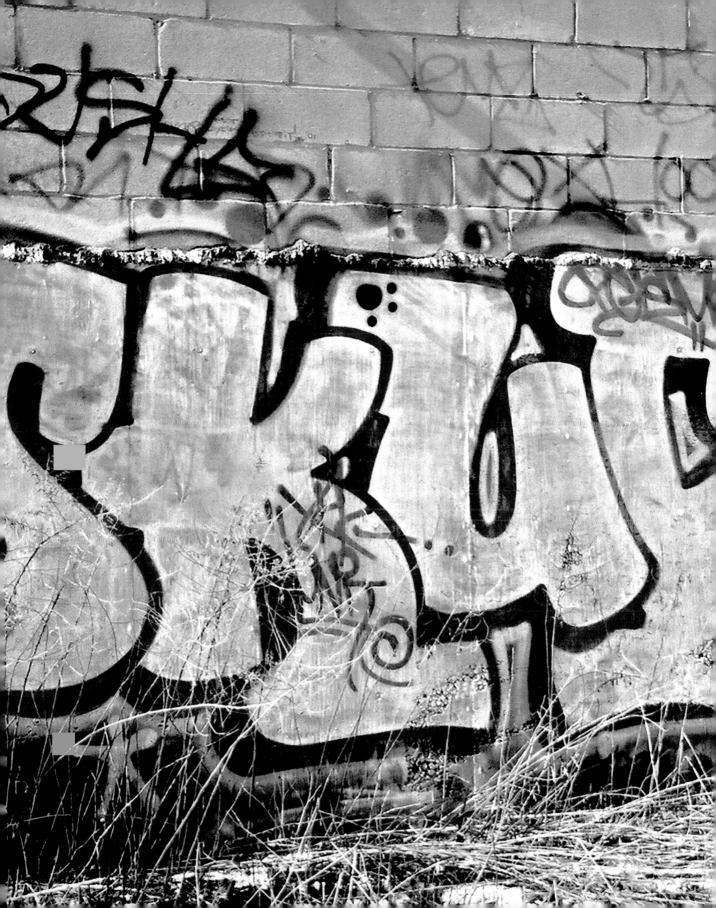

...photography credits

The pictures in this book date from 2001 to the present and were taken in the five boroughs of New York City. The date given for each picture is the year the photograph was taken, not necessarily when the name was written. Works and words by more than 100 graffiti writers are included in the book. Pictures were selected for visual interest and to represent the range of styles and personalities active in this period. This selection is as broad and comprehensive as possible—despite the ephemeral nature of the culture. We hope this 'All-City' tour of graff in NYC conveys the creative excitement of the movement today.

...acknowledgments

Special thanks to Douglas Abdell, Paola Antonelli (New York), Atlántica (CAAM, Las Palmas de Gran Canaria), Joe Bartfield, Bienal de La Havana (Havana, Cuba), Bobbito, Nicholas Boston, BRAIL, Judge John Carro (New York), CAY 161, Barrie Cline, Celia Correa, COST, DUKE, EARSNOT, Editorial Cromart (Madrid), Henry Chalfant, Richard Goldstein, GREY, Heleen van Haaren (The Hague), Ana Honigman. Steve Isenberg, JA, JOE 182, Marleen Kaptein and Stijn Roodnat (Amsterdam), Douglas Kelley, KEZ 5, Lee & Mary, Oscar M. Leo (Girona), Liz Koch, Michael Lawrence, Alain Maridueña, Marty Markowitz, Blanca Martinez, Erik Martinez, Mark Mathewson, Rich Medina, Merche, Liz Mestres, Herbert Migdol, Jan Muller (Galerie K. I. S., Amsterdam), N55, NATO, Dan Ollen, Esq. (New York), Dan Perez, Esq. (New York), the late Jack Pilsinger, Jan Ramirez, Gary Rappaport, Esq. (New York), RATE, REHAB, Sabrina Sadeghi, Yolanda Sanchez, Aaron Schneider, SI ONE, SINER, Franklin Sirmans, SKUF, SNAKE 1, Louise Sommers, Esq. (New York), DJ Spinna (New York), the late Jack Stewart, Grady Turner, TYKE, David Villorente, Allard & Wijnand Wildenburg (Naarden), and Octavio Zaya (New York).

Gratitude to the late Charles Allen Jr., Allen & Co., for his financial support.

...about the authors

NATO, born and raised in New York, made a name for himself in the graffiti community by painting his name extensively on rooftops facing the city's elevated train lines. His daredevil graffiti career came to a halt in September 2000 when he was arrested and convicted of felony graffiti. As a result, he re-channeled most of his artistic energy, showcasing his work in exhibitions at New York's Martinez Gallery. In addition to his three-year position as Graffiti Editor for YRB NYC magazine, NATO has had articles and photography appear in Atlantica, Files, Frank 151, Mass Appeal, and New York magazine. Most recently, he has been selected to participate in the Biennial of The Canary Islands.

Antonio Zaya, a native of the Canary Islands (off the coast of North Africa), has spent his entire life working in and around the visual arts, as a performance artist, painter, and poet. While he continues to produce performance art, Zaya's focus has moved towards criticism, editing, and curating, having organized dozens of group and individual art exhibitions. He has served as curator of ARCO, editor and curator of the Havana Biennial, curator of the Biennial of The Canary Islands, and editorial director of Atlantica magazine. Zaya currently resides in Girona, outside Barcelona.

Hugo Martinez is the director of Martinez Gallery in New York, America's premiere showcase for graffiti works. He has worked with the vanguard of the graffiti movement since 1972, when he helped form United Graffiti Artists to encourage collaborative work among graffiti writers and to foster their culture. In 1973 he organized the first gallery show of graffiti in New York. Over the last four decades, he opened graffiti galleries in several NYC neighborhoods before settling on a 'nomadic venue'; an approach that has attracted extensive media attention. As the foremost authority on graffiti's evolution as an art, Martinez has documented the movement extensively since its inception.

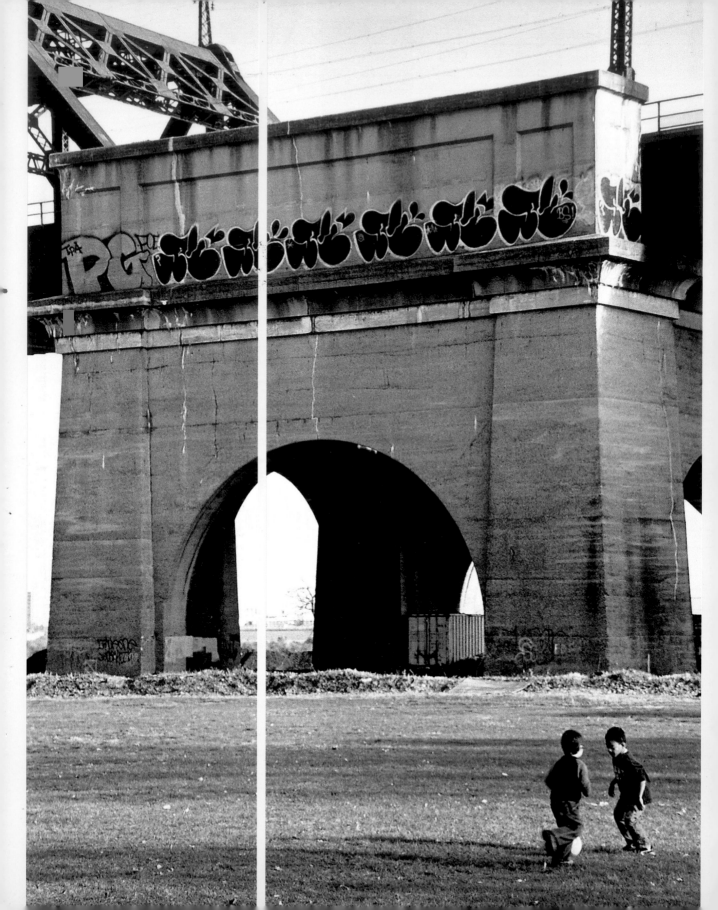